Particular Books

UK | USA | Canada | Ireland | Australia
India | New Zealand | South Africa

Particular Books is part of the Penguin Random House
group of companies whose addresses can be found at
global.penguinrandomhouse.com.

First published by Particular Books 2020
001

Text and illustrations copyright © David Gentleman, 2020

The moral right of the author has been asserted

Designed by Tom Etherington

Every effort has been made to contact all copyright holders. The
publishers will be pleased to amend in future editions any errors or
omissions bought to their attention. The images on p25 and p36 are
reproduced © TfL from the London Transport Museum collection;
Stamp imagery on p30, p31 and p35 is reproduced © Royal Mail
Group Limited; Images on p32, 33 and 34 reproduced with permission
of Transport for London; Image on p38 reproduced with permission
of the *Sunday Times* / News Licensing; Image on p48 reproduced
with permission of The Orion Publishing Group Ltd.

Printed and bound in Italy by L.E.G.O. S.p.A.

A CIP catalogue record for this book
is available from the British Library

ISBN: 978–1–846–14975–7

I'd like to thank Chloe Currens, Helen Conford, Margaret
Stead and Tom Etherington at Penguin, without whom
this book would not have taken shape; Nicola Bailey and
Daniel Davidssohn for their digital expertise and Carole
Jones for typing my draft manuscript; and my wife Sue
for her patience and her unwavering but sharp-eyed love
of London throughout our time here.

David Gentleman
My Town

An Artist's Life in London

PARTICULAR BOOKS

Contents

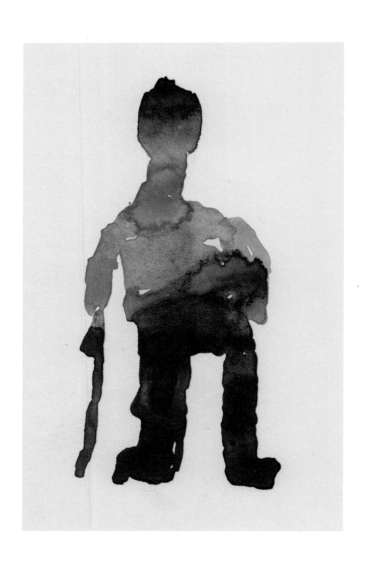

Introduction

I'm still getting used to London, though I've lived in it for almost seventy years, most of that time in the same street. A lot of it seems pretty much the same, the streets and houses, the canals and greenery and open spaces near my home, north of the river. But many aspects of the scenes and people beyond this local core are new, different and fascinating, and the city as it was when I first moved here has profoundly changed. The contrasts between how London looked then and how it is now are what this book is about. It's in three parts, and gathers together drawings from across my lifetime in the city, from my earliest sketches to watercolours made less than a month ago. The first part is about the London I got to know as a student in the early fifties and then while earning my living as a young jobbing artist, the only job I've ever had. The second is about my studio, tucked away in a quiet and leafy street in North London, and the third about some of the places within easy walking distance of it.

The book is also about drawing, and what the process of drawing brings out of me. In his poem 'Afterwards', Thomas Hardy ends the first stanza with: 'He was a man who used to notice such things'. I've come to feel that noticing things, looking more intently at them and understanding them better, is key to what drawing means. It has always made places more interesting, and made me feel more alive.

I grew up in Hertford, twenty miles north of the city – just near enough to see its red glow in the sky during the Blitz. My parents were Scottish painters who had moved down from Glasgow to find work, my mother as a weaver and my father as a poster designer. As a small boy I came to

know about London because during the week my father stopped digging the garden or painting pictures of it and disappeared after breakfast, I supposed to do some more digging, but in reality to work in a design studio in Shell-Mex and BP's tall new building off the Strand, which had a clock nicknamed Big Benzene.

My earliest trips to London were to see what he did there, but the first visit I can remember was when I was five, to see King George's Silver Jubilee procession – a long boring wait, an endless line of people walking, the train journey home in a carriage full of exhausted policemen going home themselves. On later outings I went to the Zoo and to Primrose Hill where, strangely, there were no primroses. I went on going to London from time to time during the war: once just after it started to see a pantomime; once during a lull in the Blitz to stay for a week at the Dulwich house of one of the London evacuees who were billeted with us in Hertford; later on a school trip to see *Hamlet* in the Theatre Royal, Haymarket. I went once again at the end of the war, to Oxford Street, to see an exhibition about the German concentration camps. The pull of London, with its galleries and theatres and foreign films, was strong and I was drawn back again and again throughout my teenage years.

I first came to live in London as a student at the Royal College of Art, only five years after the war. The city was shabby and many of its bomb sites were uncleared, but some of Wren's churches were still standing, as was Smith's Wharf, a beautiful warehouse beside the Thames which I drew several times. During my first year I had dreary digs near Olympia in West Kensington, then moving to Battersea, nearer to the RCA studios, which were scattered across South Kensington. I'd started off in the graphic design school, having impatiently thought it was where I was likeliest to get in; then, after a year mainly of poster designing and typography, I changed to the illustration department. I grew to like working in its printing studio, where (extraordinary at that time) we were allowed to set metal type by hand and where I could print my wood

engravings, and in the lithography studio, where I made my first prints. I also attended the painting school's life-drawing classes, having always found drawing from a living model interesting – both for learning to understand how the human form fits round its skeleton, and to appreciate its proportions, and for really noticing the way people stand, their characters, attitudes and movement. Life classes are also self-revealing – one's lack of skill can't be passed off as mere self-expression.

I was lucky to be taught by extremely good tutors, though I was perhaps influenced as much by their work and their presence as by their advice, and spurred on more by the other students than by the staff. The graphic design school was run by Professor Richard Guyatt, and its part-time staff were a remarkable mix of people whose work I already knew and liked: Abram Games and Henri Henrion, the poster designers; Reynolds Stone, the wood engraver; Edward Ardizzone the illustrator; the painters and engravers John Nash and Edward Bawden. The last three had all been official War Artists, as had Bawden's friend Eric Ravilious, whose wood engravings and watercolours I greatly admired, but who had been killed in the war. Bawden was the one I came to know best, and while a student I went several times to stay with his family in Great Bardfield, in Essex. The RCA also sometimes welcomed interesting and inspiring visiting outsiders like Barnett Freedman and Anthony Gross, lithographers and engravers, and Francis Bacon, who was for a while lent a studio in which to work on his screaming popes; he was said to have painted them with his bare forearm.

After I'd finished my course with an RCA diploma (not yet in those days called a degree) Richard Guyatt kept me on as a junior tutor for two extra years while encouraging me to take on any commissions that came my way. To begin with, these came via people my father knew or had worked with, like Jack Beddington, who had been his boss at Shell-Mex. Others came via my tutors, who passed on jobs they were too busy for or didn't want to do themselves. I left the RCA in 1955, certain only that I didn't want to commute or work in a design studio with anyone else,

but most importantly (despite knowing from my father's experience that freelancing was unpredictable and risky), hoping that I would somehow be able to earn my living on my own as an artist. I wanted only to stay afloat by drawing or painting, for whatever purpose and no matter how.

This book begins, as my working life did, with jobs for firms based in Mayfair or the West End or the City. Some of my earliest professional commissions were drawings, engravings and watercolours for press ads for tonic water and sugary drinks or vintners and brewers, big oil and chemical and pharmaceutical companies. Much later came ads for a du Pont insecticide, which turned out to blind some of the people who sprayed it. This task in particular made me think harder about what the commissions I took on were really responsible for. Even as a sixth-former I'd already begun to suspect that advertising was anti-social and parasitical. But the art directors I met were clever and helpful, it paid far better than most of my other jobs, and for the first few years it taught me a lot and helped to keep me going.

Luckily, back then and indeed throughout my career, one job led to another. I was commissioned to illustrate with wood engravings a short book called *What About Wine*, which led to more book illustrating, and drawings for newspapers and magazines and, unexpectedly, to postage stamps; the exposure these occasioned led to commissions for lithographs and screenprints, too. I also made a poster, *Visitors' London* (page 25), which, along with my engravings and designs, led much later to a mural on the Underground. All these jobs were fun to do, fuelling my self-confidence, and they took me into printers' workshops and publishers' offices. Most importantly, they enabled me to discover new subjects in the city, sometimes in parts like the river that I already loved, but often in bits of London I hardly knew.

I painted watercolours of these new subjects, and gradually started to initiate more of my work myself. And when I married a fellow RCA student, we moved away from my tiny rented flat in Battersea. Between what I was earning and an unexpected legacy, there was just enough

to buy a lease on a small converted coach-house in a then down-at-heel but quiet crescent in Camden Town. Here I had a studio of my own and I've lived and worked in the crescent (though not in the same house) ever since.

Camden Town has held my attention and interest throughout my working life: how it looks, how it's changed, the places within walking distance and the people who live, work or simply flock here, all are fascinating to me. I love to draw the rackety streets with their remnants of historic social, commercial and industrial activity (there are three ex-piano factories only a few streets away); Nash's terraces, the beautiful canal and the nearby parks, the roads and railways and, above all, the many different people, who more than anything else now make up Camden's character (even if at weekends the pavements are as crowded as Venice's with tourists). Over the years I've sketched the newly washed but still empty roads in the early morning; the afternoon visitors resting, picnicking or partying by the canal. On summer evenings, I enjoy sitting in the sun outside a pub watching the traffic and the passers-by, and I've always liked the wildlife: the seagulls on the pinnacle of Arlington House, the cormorants drying their outstretched wings on the roof of a canal barge. Once a heron flew too low and landed in our garden. Drawing even quick scribbles of these creatures fixes them in my mind.

Over time, the area has changed, tidied itself up and become gentrified, with new neighbours coming and going in the crescent. There are new high-rises and flats, buildings are better looked after; any usable spaces filled in, smaller shops and offices driven out by high rents. The canal is no longer a transporter of heavy goods; its links with the railways ceased as their discarded goods yards were sold off and redeveloped. An Edwardian theatre and music hall has vanished, leaving only its site, but another survives as a prosperous dance hall. There are more people and more traffic, and you can no longer buy real snakes and monkeys in Parkway – you have to make do with T-shirts with red buses and Union Jacks on them instead. The comfortable idea that hard and demeaning work has disappeared and

that everyone's got a job has gone. When I came to this
part of London there were no beggars; there are now.
Living and drawing here has gradually helped me to see
the city as a whole, then and now, the good and the bad, the
fascinating and the deplorable, the true and deceptive and
the bits in between.

At the heart of this book is my studio, the tools of my
work, and the joy of noticing, looking and drawing – the
urge to single out from the complexity of the world around
me something specific, and, in starting to draw or paint it,
coming to look at it more carefully, to better understand
its appearance, shape, proportions, colour, structure and
character. At a time when abstraction in art is all the rage,
representation is less fashionable. But it's too interesting
to write off. Drawing and painting can be stimulating,
surprising, puzzling, incomprehensible, accessible, obvious,
trite or boring. What is certain is that they both make one
look harder, more intently and more analytically. So I'm still
drawing, painting and noticing new things about this town,
which I've known and loved almost all of my life.

Part One

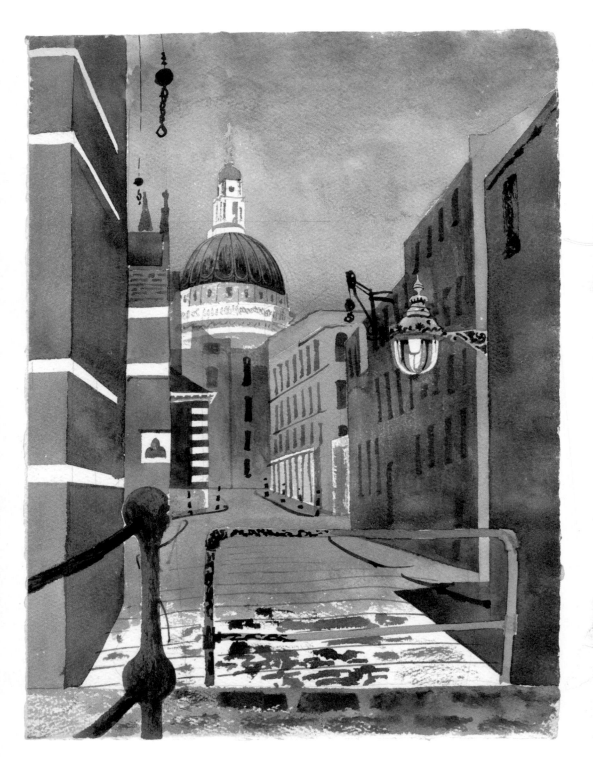

First Impressions

For an aspiring young artist, London meant independence. Even if the surroundings and my student digs were a bit bleak, my student life in London was fun, and I could always go home to my parents at weekends and in the holidays. I enjoyed walking or taking the bus to my Battersea pad despite the dreary post-war streets around it, and in 1951 the Festival of Britain's modern design and summery optimism was exciting. I was sent on exploratory architectural trips with fellow RCA students to look at Wren's St Paul's and Greenwich Hospital, and to get to know London's art galleries better: I saw my first Henry Moore work, a trio of standing women, at an open air sculpture exhibition in Battersea Park, went to the Tate (now Tate Britain) to see Mexican sculpture and American art, and enjoyed the view of what then were still industrial buildings across the Thames.

These early years taught me how to choose a possible subject and then decide on the most interesting point of view, both of which can take a while but waste less time than drawing the wrong thing. Avoiding the most obvious and therefore the most hackneyed subjects sounds sensible, even when they were what first caught your eye, but first impressions matter too and can be the truest and most vivid.

John Minton, who taught in the RCA painting school, told us to get out of the college and draw more in the real world outside. It was good advice. One summer evening I saw a gasometer not far from the end of Cheyne Walk and drew it straight off with a fountain pen on tinted paper, painting the clouds afterwards with poster paint or gouache – something I wouldn't do now.

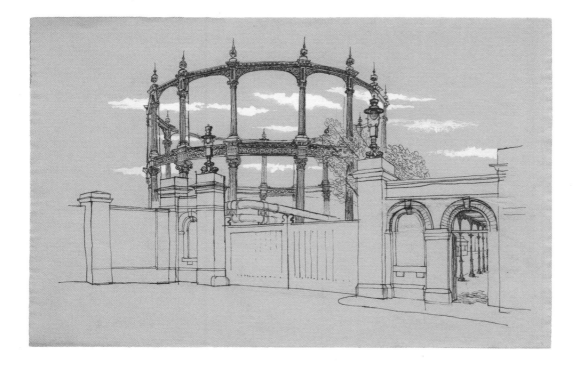

Overleaf: Smith's Wharf

Above: Fulham gasworks, 1951

Battersea riverfront, 1952

Away from the river, the semi-industrial Battersea of the early fifties was gloomier: thick smog in the winter; left-over bomb sites; the rickety-looking but indestructible railway bridges.

These student drawings were made with a fountain pen, with neither preliminary pencil sketching nor any second thoughts, so they're vivid rather then accurate.

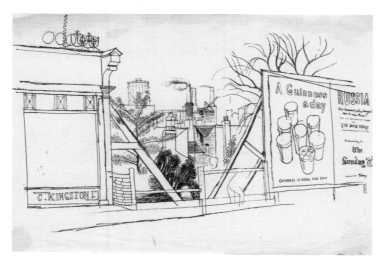

Top: Battersea from Lavender Hill, 1953

Bottom: Lavender Hill, 1953

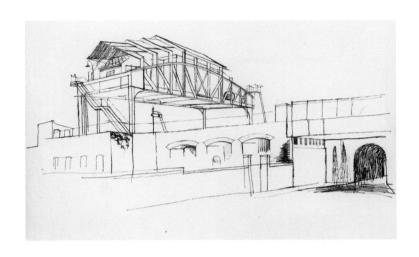

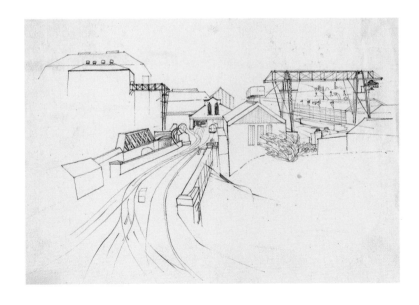

*Top: Battersea: bridge over and
the Culvert Place tunnel beneath
the Southern Region railway.*

Bottom: View from Culvert Place Bridge

The pen-and-ink sketch below was made a few years later, when I'd already started freelancing. It shows the alley leading down to the handsome Smith's Wharf warehouse, seen at low tide with swans and mud in front of it, crane cables hanging overhead. It had survived the Blitz but was already being surrounded by its even more devastating successor, the City's redevelopment.

Opposite is a more painstaking pen drawing of South Kensington – a student pastiche of a Victorian wood engraving, which may have tempted me to start wood engraving myself, a major turning point for me at the time.

The drawing beneath it shows the redevelopment just beginning, the minimal fencing-off and the self-sown green plants that had taken root after the bombing.

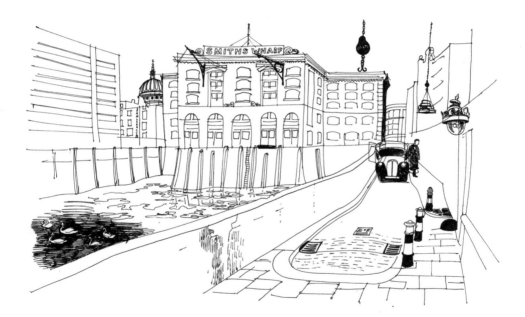

Smith's Wharf, c.1956

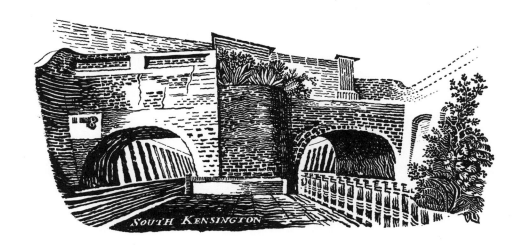

SOUTH KENSINGTON

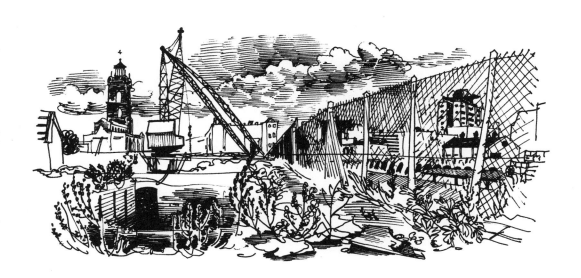

I never kept any of my student life-class drawings, probably feeling they were no good, but I did hang on to a few sketches of ordinary people in real-life surroundings. In the Leicester Square scene below the toy jumps about when the pavement salesman, or spiv in those days, squeezes whatever he's holding.

On the right is St James, Garlickhythe. In those days I seldom included people in such scenes, fearing that they would spoil the drawing; this pair of onlookers do look a bit stiff. Later on, people began to seem too interesting to leave out.

Leicester Square, c. 1956

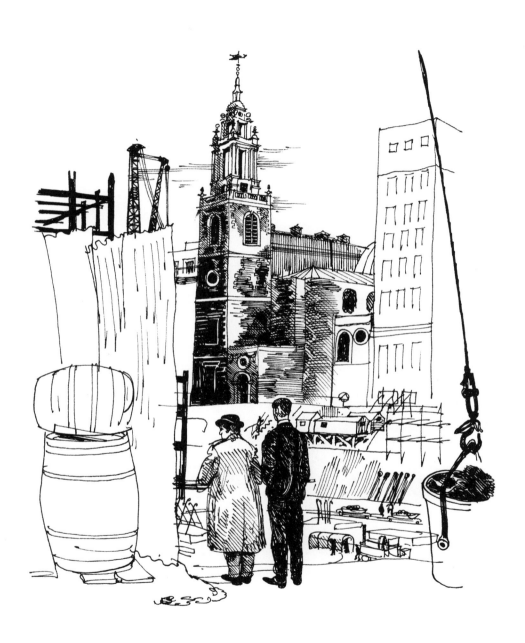

Demolition site near the tower of
St Stephen Walbrook, c. 1957

Just after I left the RCA in 1955, Penguin Books asked me to illustrate a paperback about Mediterranean cookery, Patience Gray's *Plats du Jour*, my first serious illustrated book (overleaf). Someone had warned me that opting for royalties was a gamble, so I plumped for a modest flat fee. This was a mistake – 50,000 copies were sold in the first year, and it's been reprinted and republished many times since. But Patience,

who I'd already met at the RCA, became a lifelong friend. For a while she was the *Observer*'s lifestyle columnist (she was the first) and she asked me to draw these Old Compton St and Fitzrovia shopfronts for her column. In these specialist Soho shops you could find rare and exotic items like olive oil, copper pans and pasta. I'd just bought my first car and drew the Fitzroy Street delicatessen from it. Parking was never a problem then.

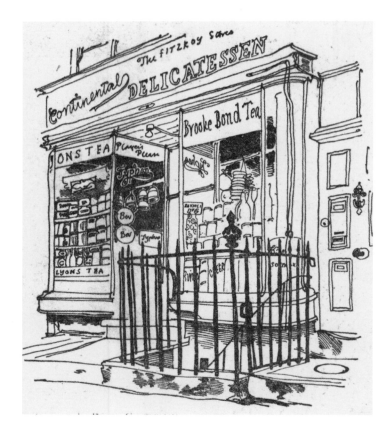

Fitzroy Street, c.1956

In those primitive days the book cover of *Plats du Jour* began as a simple black pen drawing but the grey and pink colours were drawn separately on film as overlays. Some of the peasant faces on the cover were drawn from photos in *Paris Match*: the man at the head of the table was a farmer called Gaston Dominici who had been accused of murder; the small girl was one of Picasso's daughters. I worked on very thin Whatman paper, drawing the faces over and over again until one looked about right, and then cut it out with a razor blade (no scalpels were then to be had) and stuck it down with Sellotape. Now they can just be photoshopped out.

Old Compton Street, c. 1956

*Front and back covers of first edition
of Patience's cookbook, 1956*

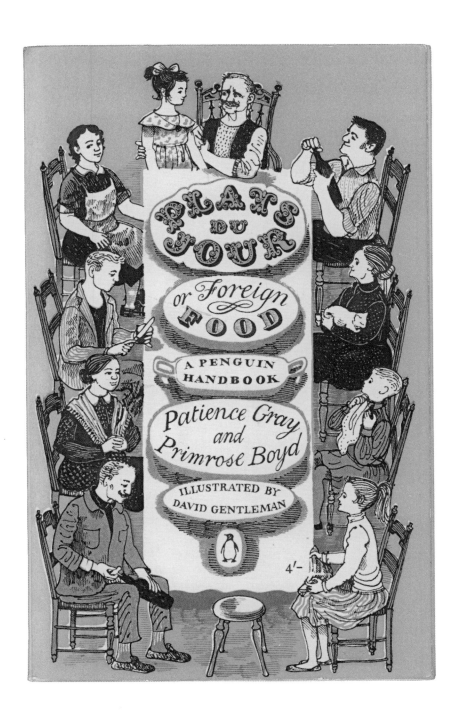

PLATS DU JOUR

or Foreign FOOD

A PENGUIN HANDBOOK

Patience Gray
and
Primrose Boyd

ILLUSTRATED BY
DAVID GENTLEMAN

4/-

I drew Covent Garden's Old Floral Hall, then at the corner of Covent Garden's piazza, while designing the poster *Visitors' London* for London Transport. The drawing below is a study for it, where its interior can be glimpsed through the bottom arches. Unlike the *Plats du Jour* covers, for which I'd had to make black, pink and grey colour separations, the finished poster design was reproduced in four-colour half-tone, so it could be painted in watercolour, the medium I've liked since boyhood. I painted it on a large but inconveniently circular dinner table in my Battersea flat, and felt proud to see it whenever I went on the tube.

Above: Old Floral Hall, Covent Garden piazza, 1955

Opposite: London Transport poster Visitors' London, 1956

The Tower of London: wood engraving
for paperback cover, c. 1973

Most of my early wood engravings were quite small, which may have been why I was asked out of the blue to design some stamps. After three different sets had been issued, I wrote to the new Postmaster General, Tony Benn, suggesting that stamps could be made more popular if their subjects were more interesting and the familiar photographic image of the Queen was dropped or formalized. Benn then commissioned me to design the 'Gentleman Album' to show how new subjects like British architecture, history and science might work as stamps. For the design below I engraved the old London Bridge at four times stamp size, reversed a proof to serve as a reflection, and added some colours with Letrafilm. This stamp was essayed but never issued, but over the years 103 of my stamps were. Changes of scale were never a problem; about twelve years later I used wood engravings of roughly the same size as this one but twenty times enlarged for the murals in Charing Cross tube station.

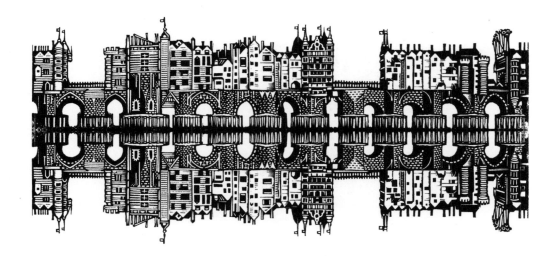

Old London Bridge: wood engraving
for an unissued stamp, 1966

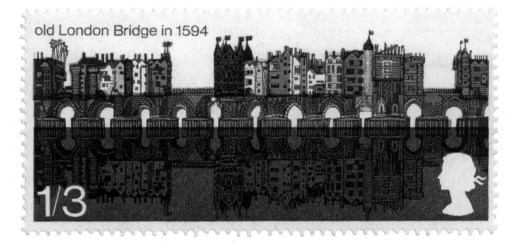

old London Bridge in 1594

1/3

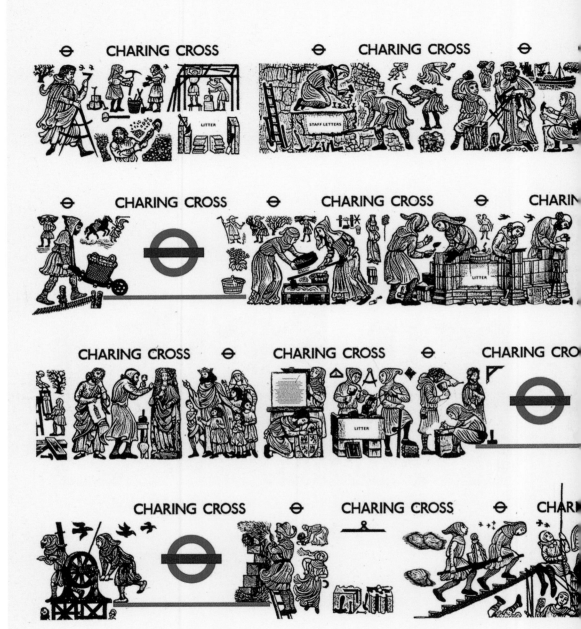

Wood engravings for Underground station platform mural, 1978

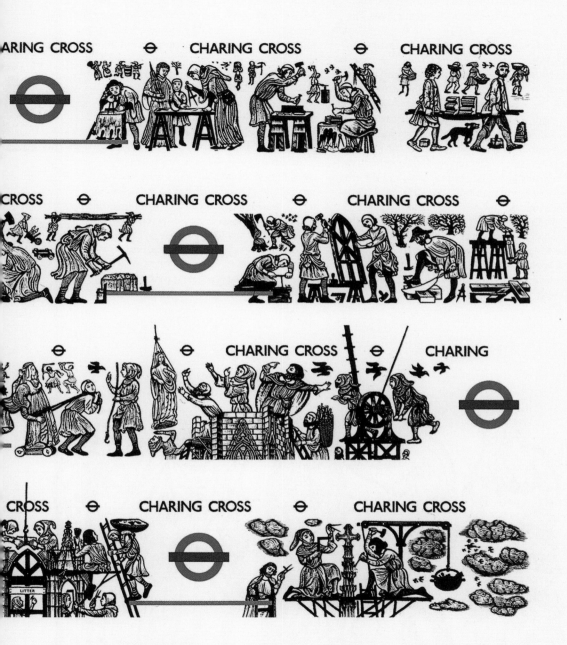

The Charing Cross commission also arrived quite unexpectedly, with a call from Michael Levy, London Transport's publicity chief. The brief was simply to design a mural for an Underground station that would relate somehow to the station's name, Charing Cross. There was no interference from design management, then a newly arrived and suspect discipline, to complicate the task. The platform-length mural would be made up of about sixty separate melamine panels and designed around the station name and logo wherever they appeared, the wooden benches (since sadly replaced) below them, various letter-boxes and rubbish bins, and the entry and exit openings along the platforms. I began by laying all these out on a blank sheet and drawing even my very earliest roughs over them, and quickly thought of using the spaces between the openings as if they were panels in a medieval book of hours or a comic strip, to show how the original Eleanor Cross, after which Charing Cross is named, had been built.

The medieval characters were the same size as the platforms' passengers and would stand beside them or roll their wheelbarrows onto the same wooden benches. My references were from illustrations in medieval manuscripts of building methods and early cranes, barrows, scaffolding and stonemasons. I photographed these and made a card index of them. But in Westminster Abbey, then being restored, it was strange to find today's stonemasons using exactly the same templates, tools and ways of working as their medieval predecessors.

It was a wonderful task. At the outset I worried that the whole thing might quickly be obliterated by graffiti, but LT's chief architect, Sidney Hardy, said that if the public were treated with respect it would be returned. (He added that he would anyway be laying in plenty of solvent just in case.) In the end any occasional graffiti, even the funny ones, looked puny against the strong black engraved images, which are still there today.

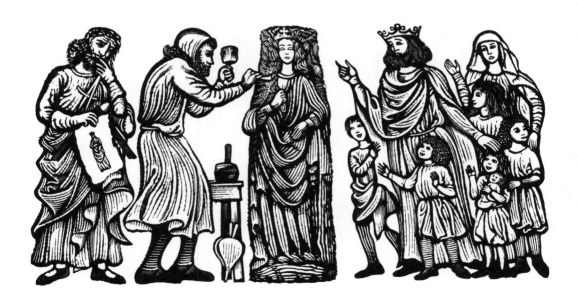

Wood engraving for
Underground station, 1978

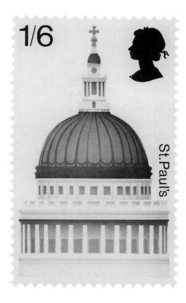

Left: Detail of wood engraving
for mural on cruise ship
Spirit of London, *1975*

Right: Unselected design for a
postage stamp competition, 1968

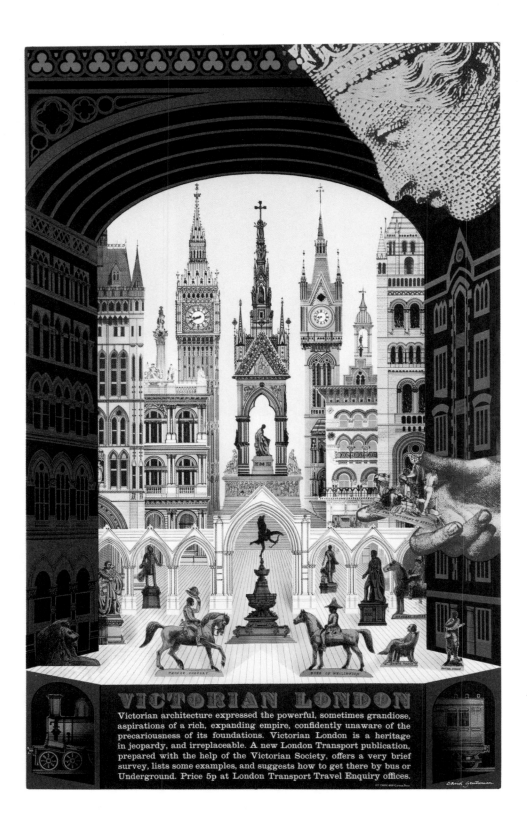

VICTORIAN LONDON

Victorian architecture expressed the powerful, sometimes grandiose, aspirations of a rich, expanding empire, confidently unaware of the precariousness of its foundations. Victorian London is a heritage in jeopardy, and irreplaceable. A new London Transport publication, prepared with the help of the Victorian Society, offers a very brief survey, lists some examples, and suggests how to get there by bus or Underground. Price 5p at London Transport Travel Enquiry offices.

Sights

The monumental London I knew in the sixties
and seventies was still largely Victorian but it was
beginning to change. At the beginning of the sixties
I made a series of drawings for *The Sunday Times*
to show how Central London was about to look in
the new decade: imaginary aerial views of a new
dual carriageway and big hotel for Park Lane, a new
Shell Building opposite the Victoria Embankment,
and a pedestrianized Leicester Square. While I
was drawing on the pavement there a passer-by
stopped to ask crossly why I didn't get a proper
job, but taking the drawing along to *The Sunday
Times'* deputy editor, fierce-looking behind his green
eye-shades, felt proper enough.

 This commission was one of many which would
lead me to sketch, draw and paint watercolours
of London's most familiar sights, like Covent
Garden, Westminster Abbey and the Foreign and
Commonwealth Office, Buckingham Palace and
Downing Street, the last looking by today's more
paranoid standards surprisingly vulnerable. The
toy theatre-like poster (opposite) for London
Transport was especially fun to research and design.
I drew the architecture as precisely as possible
with rulers, set squares and Rotring pens and then
sprayed the colours on with an airbrush. Adding
Queen Victoria's head from the Penny Black stamp
was a afterthought.

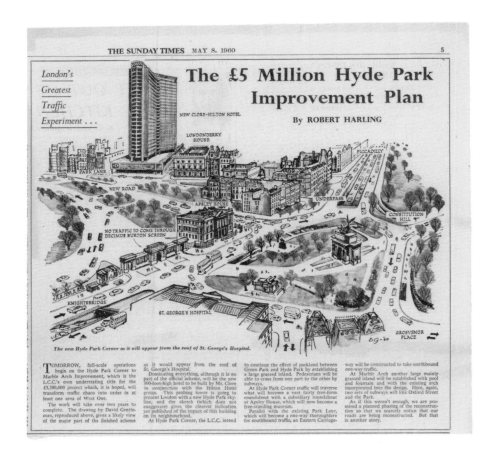

London's Greatest Traffic Experiment . . .

The £5 Million Hyde Park Improvement Plan

By ROBERT HARLING

NEW CLORE-HILTON HOTEL

LONDONDERRY HOUSE

PICCADILLY

PARK LANE

NEW ROAD

APSLEY HOUSE

UNDERPASS

CONSTITUTION HILL

NO TRAFFIC TO COME THROUGH DECIMUS BURTON SCREEN

KNIGHTSBRIDGE

ST. GEORGE'S HOSPITAL

GROSVENOR PLACE

The new Hyde Park Corner as it will appear from the roof of St. George's Hospital.

TOMORROW, full-scale operations begin on the Hyde Park Corner to Marble Arch Improvement, which is the L.C.C.'s own understating title for the £5,380,000 project which, it is hoped, will transform traffic chaos into order in at least one area of West One.

The work will take over two years to complete. The drawing by David Gentleman, reproduced above, gives a likely view of the major part of the finished scheme

as it would appear from the roof of St. George's Hospital.

Dominating everything, although it is no part of the official scheme, will be the new 300-foot-high hotel to be built by Mr. Clore in conjunction with the Hilton Hotel group. This probing tower is going to present London with a new Hyde Park skyline, and the sketch (which does not exaggerate) gives the clearest indication yet published of the impact of this building on its neighbourhood.

At Hyde Park Corner, the L.C.C. intend

to continue the effect of parkland between Green Park and Hyde Park by establishing a large grassed island. Pedestrians will be able to cross from one part to the other by subways.

At Hyde Park Corner traffic will traverse what will become a vast fairly free-form roundabout with a subsidiary roundabout at Apsley House, which will now become a free-standing museum.

Parallel with the existing Park Lane, which will become a one-way thoroughfare for southbound traffic, an Eastern Carriage-

way will be constructed to take northbound one-way traffic.

At Marble Arch another large mainly grassed island will be established with pool and fountain and with the existing arch incorporated into the design. Here, again, two sets of subways will link Oxford Street and the Park.

As if this weren't enough, we are promised a planned phasing of the reconstruction so that we scarcely notice that our roads are being reconstructed. But that is another story.

William Morris' Kelmscott
House in Hammersmith, lithograph, 1969

Langley Street, Covent Garden:
lithograph for exhibition poster, 1980

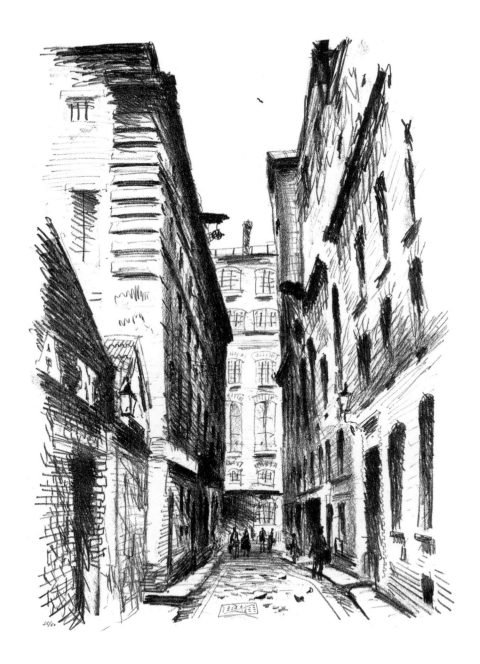

The lithograph opposite, which became the poster for a series, was drawn straight off one Sunday morning on a zinc plate balanced on the roof of my car. The tall buildings still served as warehouses storing fruit and vegetables then; now they're shops or dancing schools.

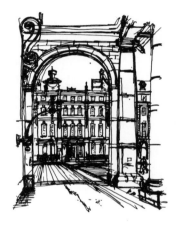
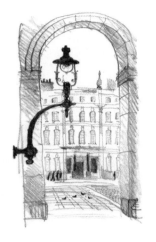

Sketches for Covent Garden
lithographs, 1972/80

Apart from the Langley Street poster, almost all my lithos in those days were printed in several colours. I had first to make a simple key drawing – a guide which was then transferred onto each of the other zinc plates before I drew on them, but was not itself printed. Each different colour was drawn over such a key. These images needed precision but couldn't have the Langley Street poster's freedom.

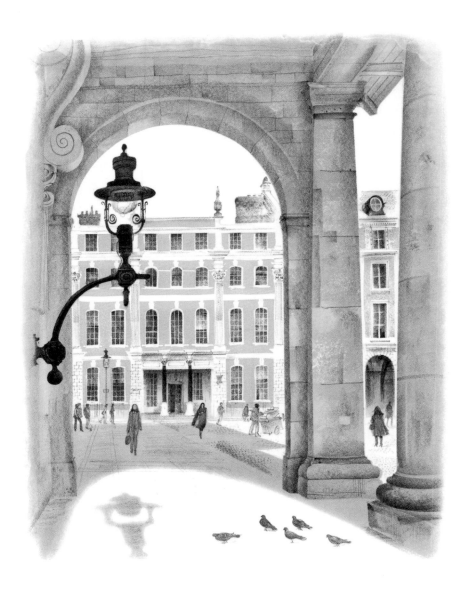

Above: 43 King Street,
Covent Garden, 1980

Opposite: Mercer St/Shelton St/
Monmouth St, lithograph, 1972

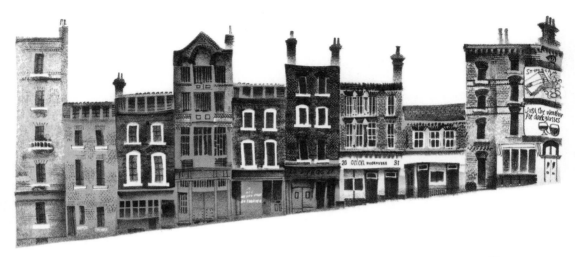

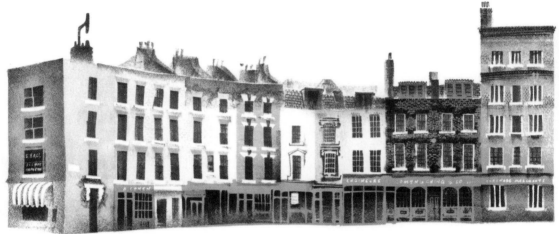

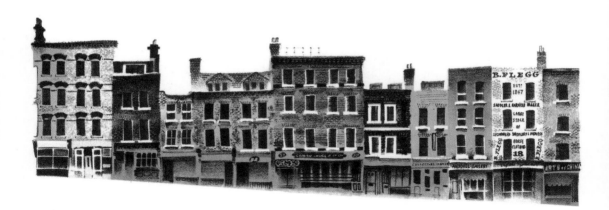

The old Covent Garden flower market is now the London Transport Museum. In 1972 anyone who got up early enough could still go in and buy a bunch. On this early print all the drawing is on the black litho plate, while the four colours (pale green, darker green, pale grey, grey-blue) are each drawn on separate plates. The colours are stronger on the later lithograph (opposite)

of the imposing gateway into St Giles-in-the-Fields. Beyond it on the right were the premises of the theatrical scenery makers Brunskill and Loveday. In 1956 this renowned firm had built my one and only stage set for *Roseland*, a musical play which ran in the West End for just a week, mercifully putting paid to any notion I might have had of becoming a stage designer.

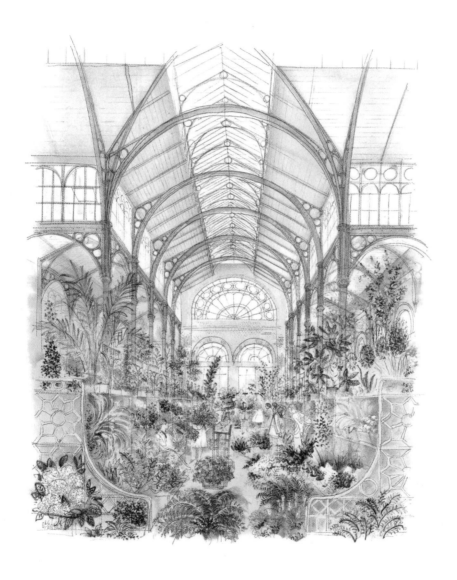

Foreign Fruit Market, Covent
Garden, lithograph, 1972

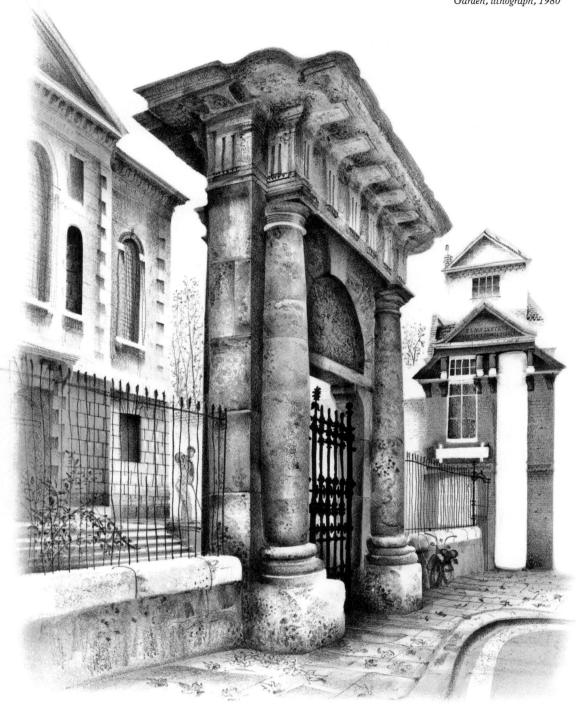

St Giles-in-the-Fields, Covent Garden, lithograph, 1980

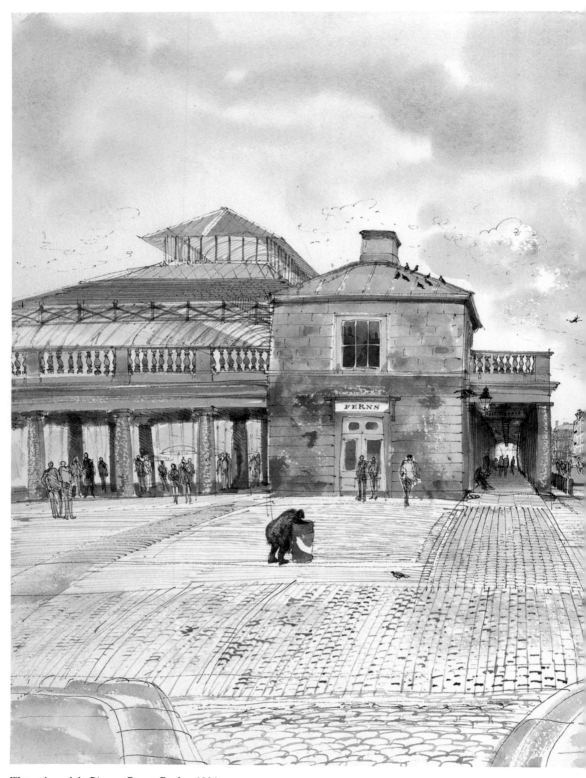

Watercolour of the Piazza, Covent Garden, 1984

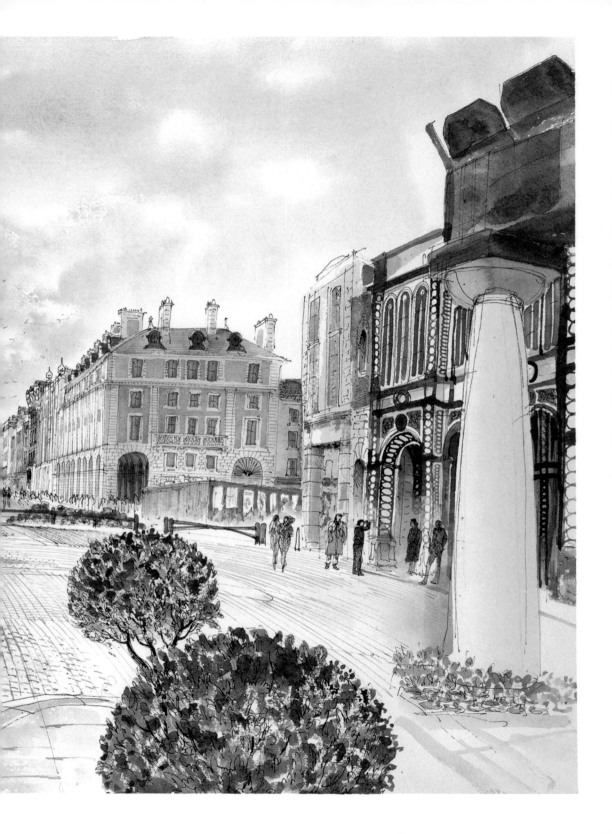

The drawing below was made for a book about Westminster Abbey and the one opposite was a sketch for a larger watercolour commissioned by the Foreign and Commonwealth Office. They reflect the contrast between the two great buildings: the Abbey's Gothic sobriety and simplicity and the FCO's excited Palmerstonian flamboyance.

The FCO, like the Albert Memorial and the Midland Grand Hotel at St Pancras station, was designed by Sir Gilbert Scott, but unlike them in classical style. It was built in mid-Victorian times in 1861–68. This quick sketch of its great staircase helped me decide which of its interiors to draw in greater detail. I loved the feeling of drawing in a great building at work, free from other intruders.

Westminster Abbey: the crossing, 1990

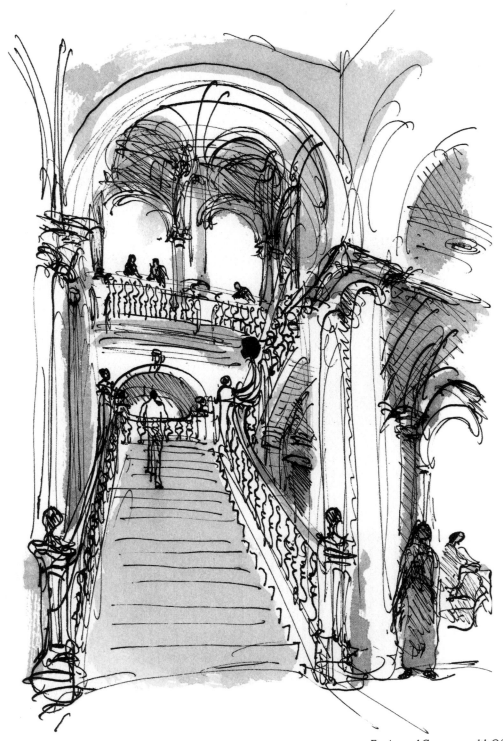

*Foreign and Commonwealth Office:
the Grand Staircase, 2005*

Downing Street, c. 1983

I drew these gateways to Downing Street and Buckingham Palace in the eighties. Downing Street even then looked more barricaded than I remembered from previous visits when anyone could just walk up it and look at Number Ten unhindered. Buckingham Palace has never looked particularly vulnerable, just majestically impossible to get into. But in July 2019 someone did manage to clamber over its gates in the middle of the night.

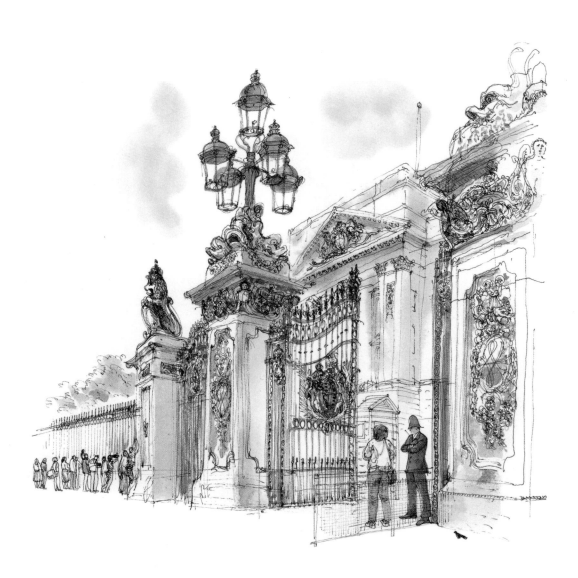

Buckingham Palace, c. 1984

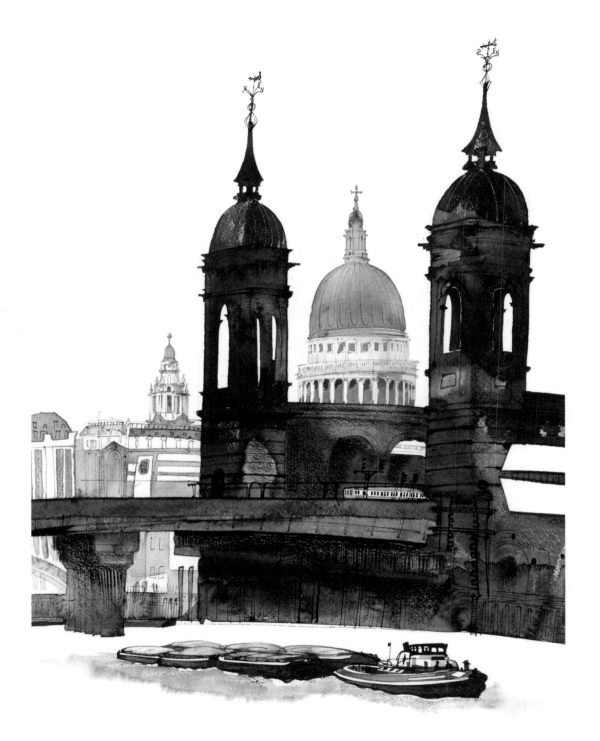

River

In the early days I most liked wandering about and drawing the river and the views across it. Back then the Thames was still a romantic, industrial place of cranes, derricks, lighters and docks. There were only a few really tall buildings sticking up: Big Ben, the Shot Tower, St Paul's, Tower Bridge, the power stations. Even in the sixties, immense lock-gates still opened to let ocean-going liners into the deep-water docks on the Isle of Dogs, and big ships were still docking upstream in the old Pool of London as far west as London Bridge. But already the skyline seen from the embankment was changing; its offshore structures had vanished and the people in the riverside pubs were office workers instead of dockers. Today the older towers are dwarfed by even bigger ones, and much of the riverside beyond Vauxhall is being damaged by glossy developments that use up the best riverside sites. But even if the cranes and the old romantic-looking warehouses that had survived the Blitz have vanished, the stretch from Tower Bridge to Westminster is still beautiful, and the river still irresistible to draw, with its sparkle and menace; its beauty, contrasts and indestructible vastness; its constant tidal ebb and flow; its occasional accessible beaches of imported sand and its riverbed of old bricks, rubbish and mud. The river is London's oldest asset, and it is also perhaps the single London feature that seems indestructible.

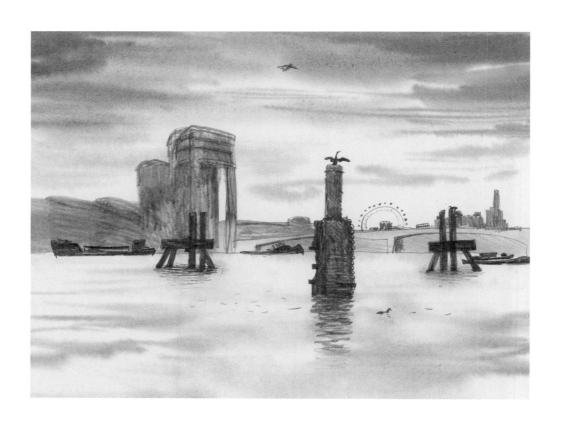

*Overleaf: St Paul's and Cannon Street
station from London Bridge, 1984*

*Above: Dolphins (wooden offshore
mooring points), cormorant and
London Bridge, watercolour, c. 2007*

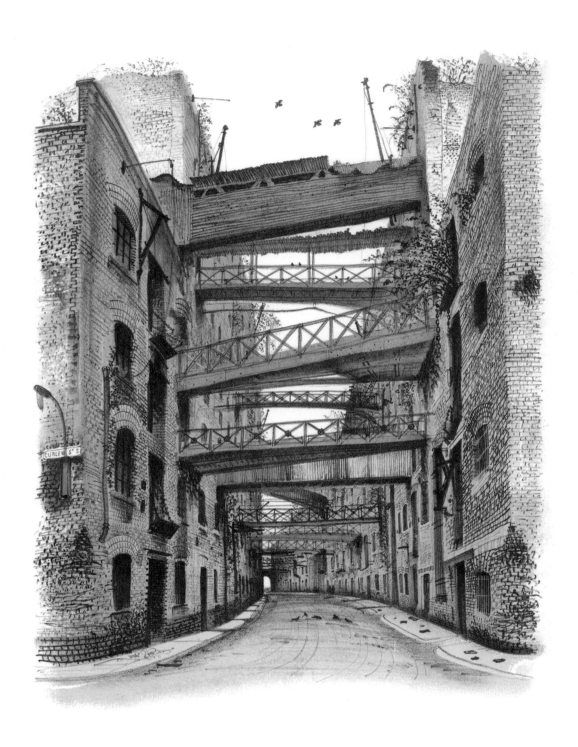

Shad Thames near Curlew Street, lithograph, c. 1983

Distant views of the heart of London are the
river's greatest offering. The sketch below was
made from the Oxo Tower wharf at low tide
when the high-rise City was just being built.

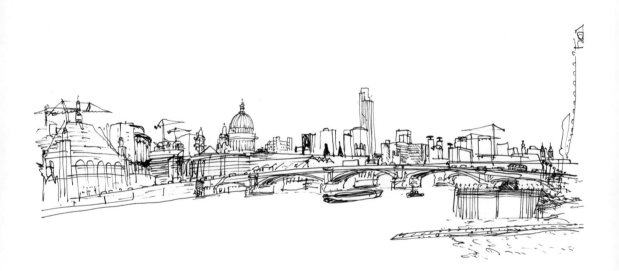

Blackfriars Bridge and the City
from the Queen's Walk, c.1990

There are still several sets of steps down to the shore of the Thames; these (below) are from Custom House Quay. I made this pen and watercolour drawing from the bottom of the steps at the far end of Custom House Quay and finished it as my feet got wet.

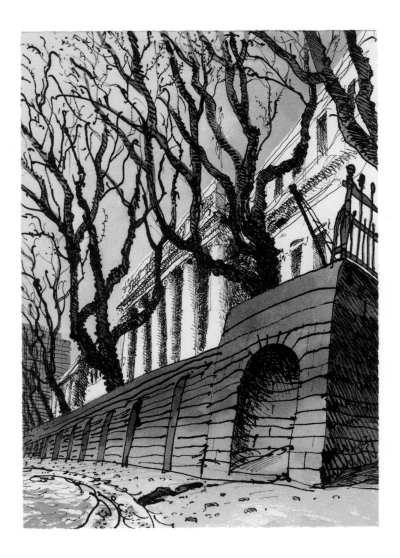

Custom House Quay from the foreshore, c. 2000

This black-and-white lithograph of Canary Wharf being built was commissioned for a building magazine based nearby. I'd never seen so many cranes at once. I used to take the Docklands Light Railway with our young son, explore the transformation under way, get something to eat at the Island Gardens and then walk through the Greenwich foot tunnel under the Thames to Greenwich and the *Cutty Sark* and look back at London from the Royal Observatory.

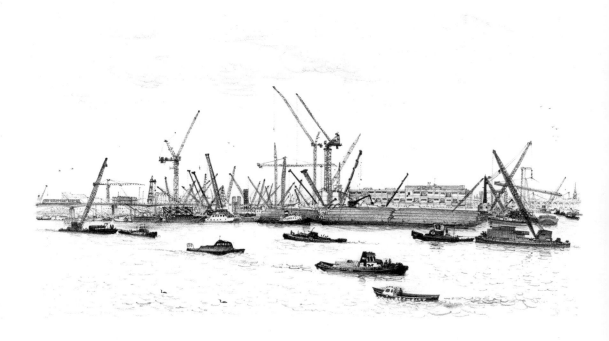

Above: Canary Wharf under construction c. 1991

Opposite: St Magnus-the-Martyr, the Monument and the NatWest Tower from the Queen's Walk, c. 1998

Top: St George Wharf
development and tower, 2018

Centre: Hungerford Bridge and the
London Eye from Westminster, 2019

Bottom: Albert Bridge and
Chelsea Harbour flats, 2018

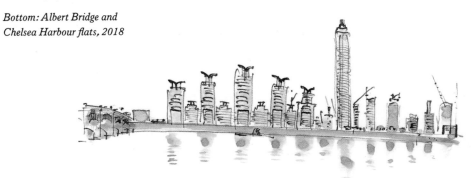

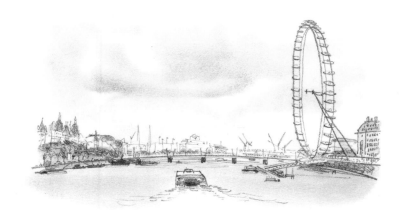

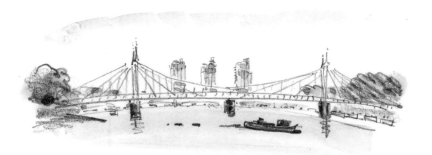

Some of the lovely distant views across and up and down the river, even from somewhere as famous as Westminster Bridge or Chelsea Bridge, have been obscured by eye-catching newcomers. Now, the view straight across the river towards Nine Elms from Crown Reach just upstream from Vauxhall Bridge is dominated by a row of the ugliest tall flats in London.

I drew the City from the top of the Shard two days after it opened, with the half-built Walkie-Talkie still rising in the middle, toy-like boats in the Thames and tiny trains snaking about at my feet. From up here the City suddenly seemed both model and muddle – a crowded hotch-potch in which its once-familiar landmarks were already becoming hidden treasures.

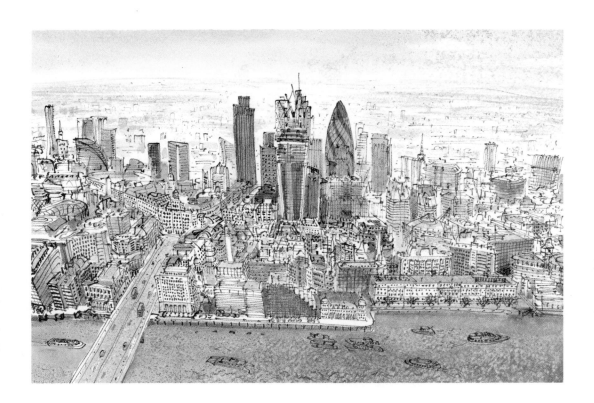

The City skyline from the top of the Shard, with the Walkie-Talkie (20 Fenchurch Street) under construction, 2013

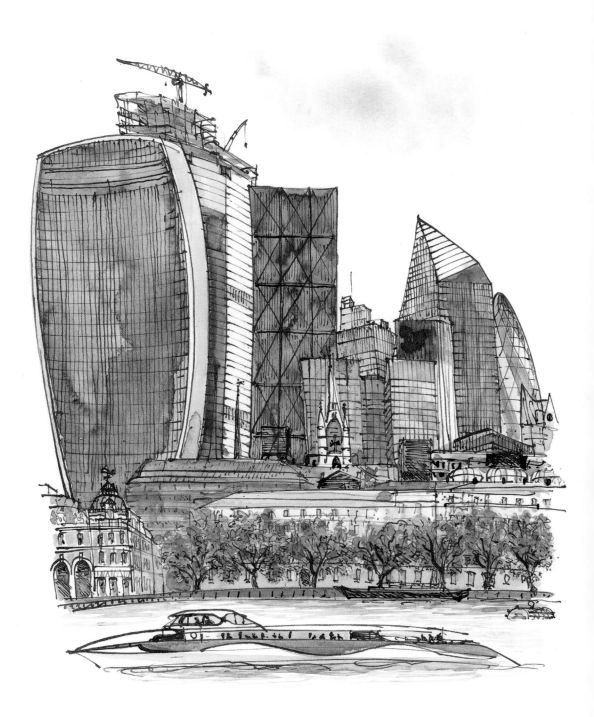

City

I've been drawing the City of London since the fifties. I began by making wood engravings for Christmas cards, calendars and posters, and later, watercolours for hanging in City offices and later still, in the eighties, for a book of my own. Around 1999, for an exhibition, I drew the people crossing London Bridge on a chilly morning rush hour and afterwards went to a now-vanished café at the end of the bridge for a warming cup of tea, hardly registering the only other customer who was too tired and shabby-looking to even notice until he got up to leave just as I did, suddenly realizing he was my own reflection.

By getting to know the City when it was still largely Victorian, I grew to notice and like the contrasts between the beautiful churches and public buildings from the seventeenth century onwards to Edwardian times. I first saw its historic street names like Poultry and Fish Street while wandering about exploring with my son when he was young, and noticing the old confusing City ground plan which survived the 1666 Great Fire of London and Wren's attempts to rationalize it. These historic streets and Wren's and Hawksmoor's churches are now getting buried amid the tall new glass and steel buildings. But the new buildings, with their clean and often simple outlines, have their own beauty and allure, their glazed surfaces reflecting those of their neighbours as if in an open-air hall of mirrors.

St Giles-without-Cripplegate is a striking City remnant within the Barbican. St Giles was the patron saint of lepers, beggars and the disabled. The church was gutted in the Blitz but later restored. The City's first high-rises, easily identified by their projecting balconies, were the three tall Barbican tower blocks.

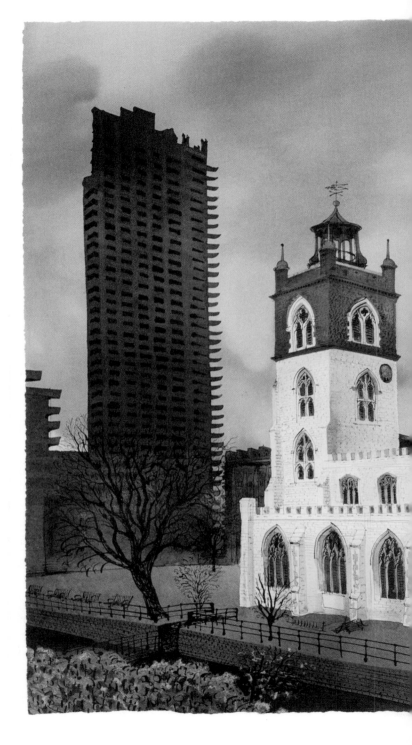

Overleaf: The new City from the Walkie-Talkie to the Gherkin, seen from the Queen's Walk, 2019

Right: St Giles-without-Cripplegate in the Barbican complex, with the three tower blocks: Cromwell, Shakespeare and Lauderdale Towers, 1999

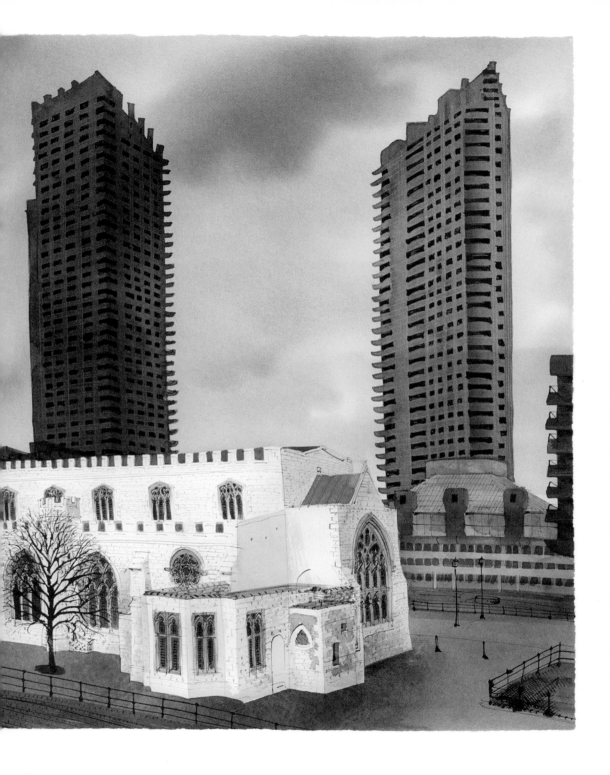

This corner building in Queen Victoria Street reflects Victorian detail, repetition and a heady suggestion of wedding cake. It had just been restored and repainted when I drew it but it needed a dark sky to dramatize it.

The trio of buildings opposite were each skyscrapers or at least high-rises in their day. NatWest was the first of the City's tall office blocks; its hexagonal ground plan and section conveniently echoed the company's logo. Lloyd's of London was designed by Richard Rogers with the same inside-out characteristics as the Pompidou Centre in Paris, which Rogers had previously co-designed with Renzo Piano, later the architect of the Shard. The corner tower of the White Tower, the old keep of the Tower of London, now looks comfortingly white only in certain lights or when floodlit.

Albert Buildings, Queen
Victoria Street, 1998

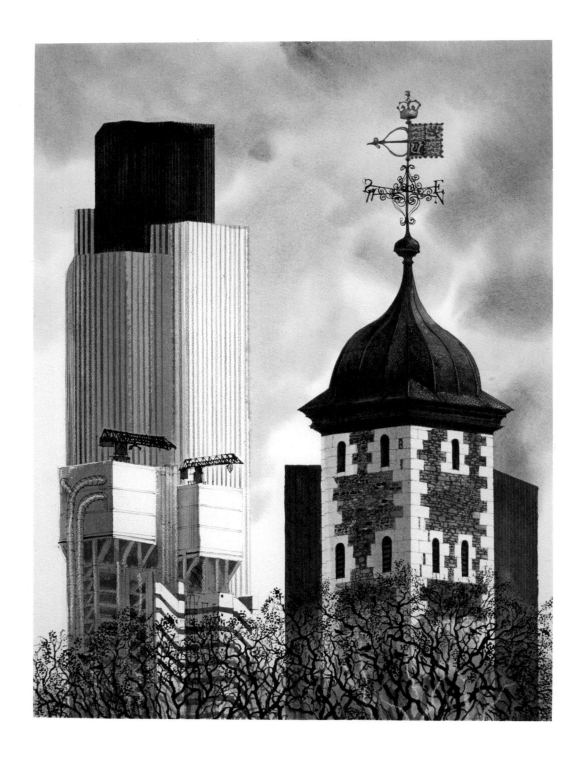

*The NatWest Tower, the Lloyd's
building and the Tower of London, 1999*

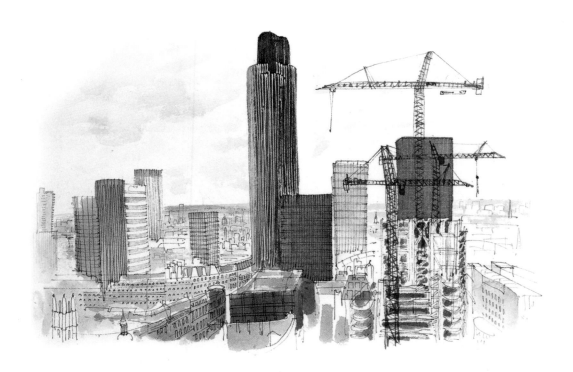

In 1984 a friend who worked there invited me to make some drawings from the top of an early and moderately high-rise office block at 20 Fenchurch Street, which has since been replaced by the Walkie-Talkie. I made the drawings from the terrace surrounding the executive suites where luncheon tables were being laid just behind me. The sketches show a now-vanished City as it was before the arrival of the Gherkin, Walkie-Talkie and Shard – a place that would be unrecognizable now. The NatWest Tower and the beginnings of the shiny new Lloyd's of London were already there, but only a few cranes could be seen compared with the cluster around St Paul's two decades later and the myriads there today.

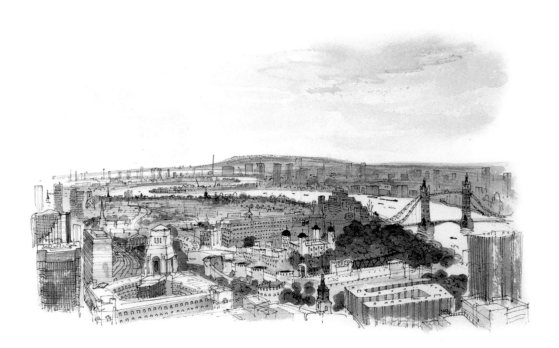

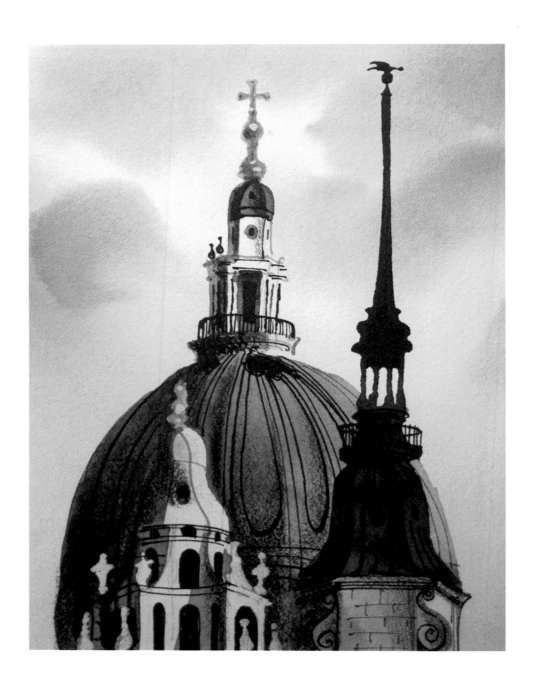

St Paul's, St Martin Ludgate and the Old Bailey,
Newgate Street, from Fleet Street, 1998

In the late nineties, while painting for a millennium exhibition, I looked afresh at the transformations in and surrounding the City and was struck by how familiar landmarks, like those in the watercolour opposite, were gently slipping out of sight. Nearby, the immense new office blocks spreading over London Wall were turning people and traffic alike into insects. The drawing below was made with a fountain-pen ink, which flowed better than Indian ink but spread into the drawing when I brushed washes of tapwater across it – not as it turned out disastrously, but unpredictably and quite usefully.

London Wall looking west, 1999

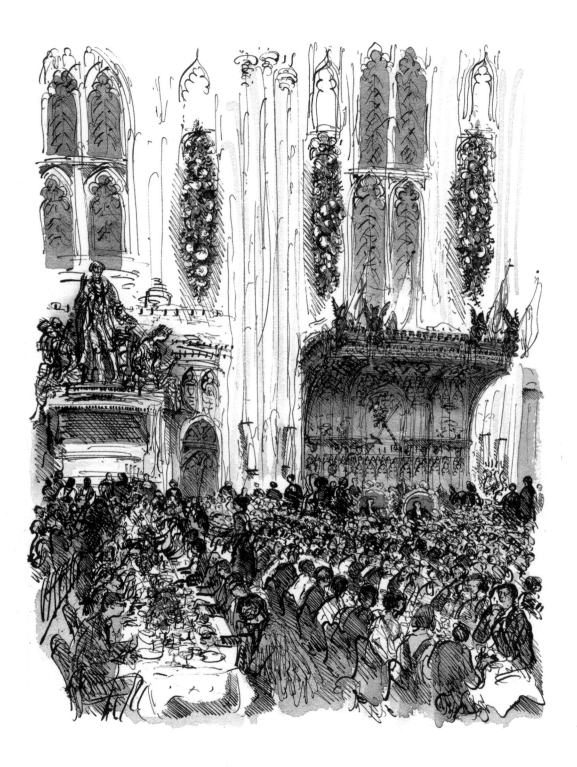

City

Commissions have led me to various contrasting
subjects, ceremonial, professional or manual.

*Opposite: The Lord Mayor's
Banquet at Guildhall, 1999*

*Above: Bummarees at Central
Markets, Smithfield, c.1990*

The city is now full of shiny metal.

*St Andrew Undershaft and Lloyd's
of London, Leadenhall Street, 1999*

*Top: The domes of St Paul's
and the Old Bailey, c. 2006*

*Bottom: Smithfield Long Lane
from Holborn Viaduct, c. 2006*

These images reflect the contrasts of style, media and technique, between the quickly drawn pen-and-ink sketches with watercolour added later and the larger and more diagrammatic or poster-like picture opposite, showing three different architectural styles: George Dance's classical Mansion House façade and James Stirling's No 1 Poultry, with Wren's steeple of St Mary-le-Bow in the distance.

Left: Threadneedle Street, Bank and Royal Exchange from Mansion House, 1999

Right: Mansion House, 1999

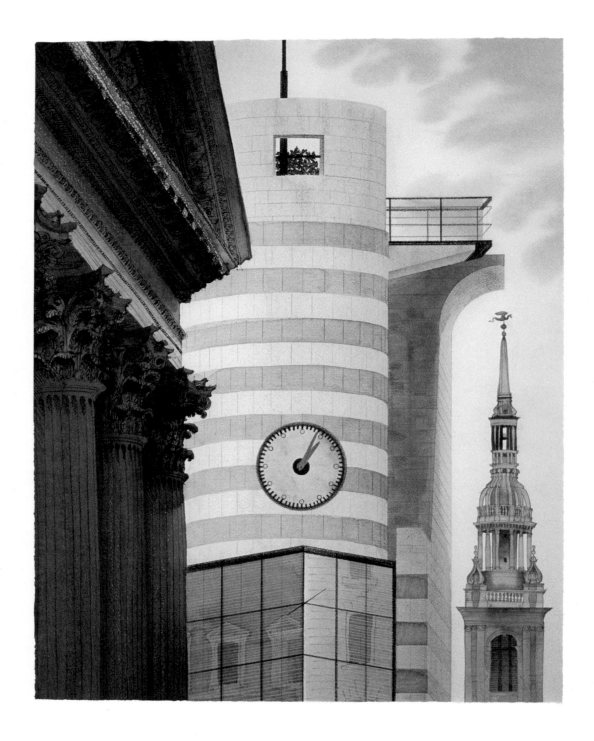

*Mansion House, No 1 Poultry
and St Mary-le-Bow, 2000*

Distance brings things close to each other –
high-rise housing and commerce, the eighteenth
century and the twenty-first, stone and steel.
The City streets are now thronged with visitors
as well as workers but Sunday morning is
a good time to look at them when everything
is relatively empty and quiet.

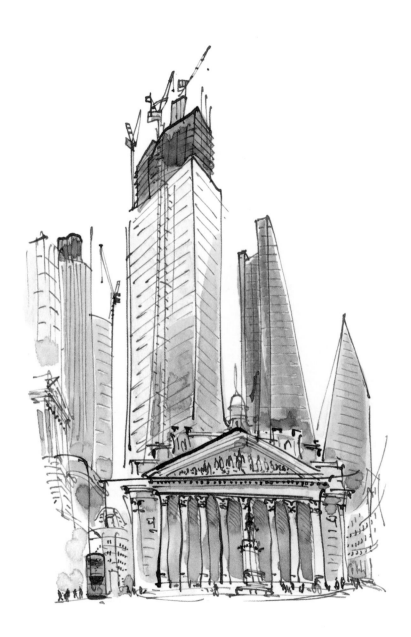

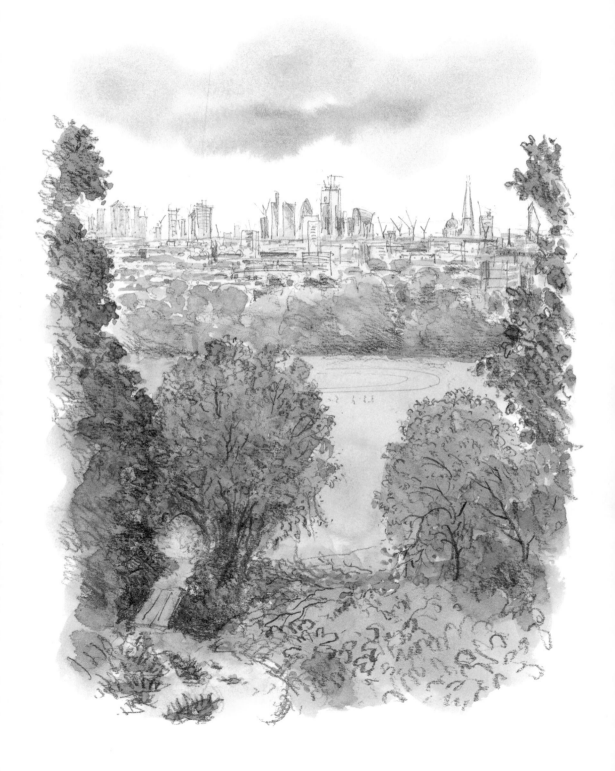

Heath

There are two southerly approaches to Hampstead Heath's Parliament Hill; either of them will take you to the best views of the City and the West End.

The heath itself is far bigger, wider, hillier and more varied than any other open space in London. Walking across it is delightful and exhilarating, and drawing it is like being in the country. Different bits of it have their own character. There are the kite flyers and the panorama from the heights of the hill; the ponds at the heath's edges, connected by streams, home to swans, ducks and seagulls; the undulating slopes of the main central area, threaded with trees and stretches of woodland – and although there are plenty of paths it's still quite easy to lose one's way there, though never for very long.

Because there is so much unsheltered space on the heath, weather and season greatly affect one's impressions of it. In spring, its wild flowers grow densely on the slopes, and there are acres of buttercups in the meadows. In late summer, the long grass turns yellow, and the trees become a good foil to the distant City and Canary Wharf. In autumn, as the leaves drop off, you can see through copses and woodland again. In winter, the paths get muddy and slippery and the whole heath seems wilder and bleaker, but remains as lovely as ever. I first came here to escape the city bustle sixty-seven years ago and I've been returning ever since.

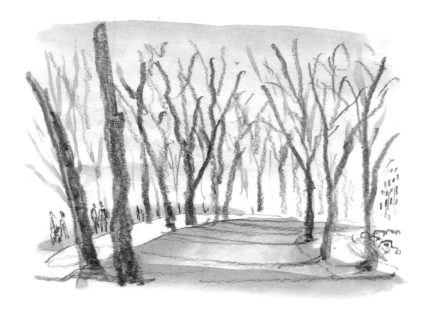

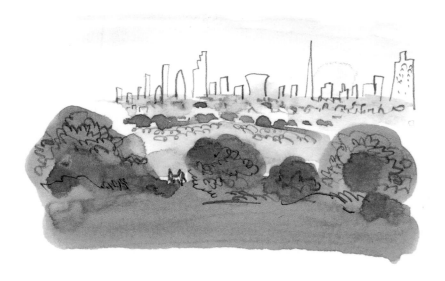

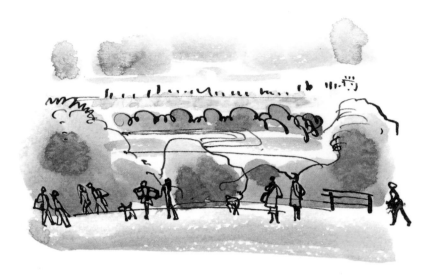

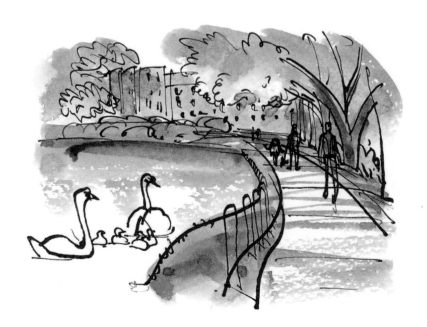

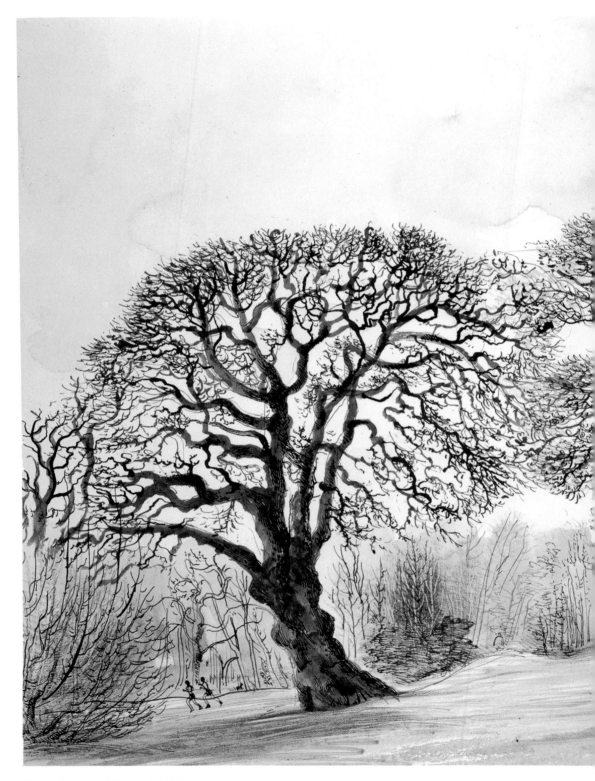

The southern edge of Kenwood, 1984

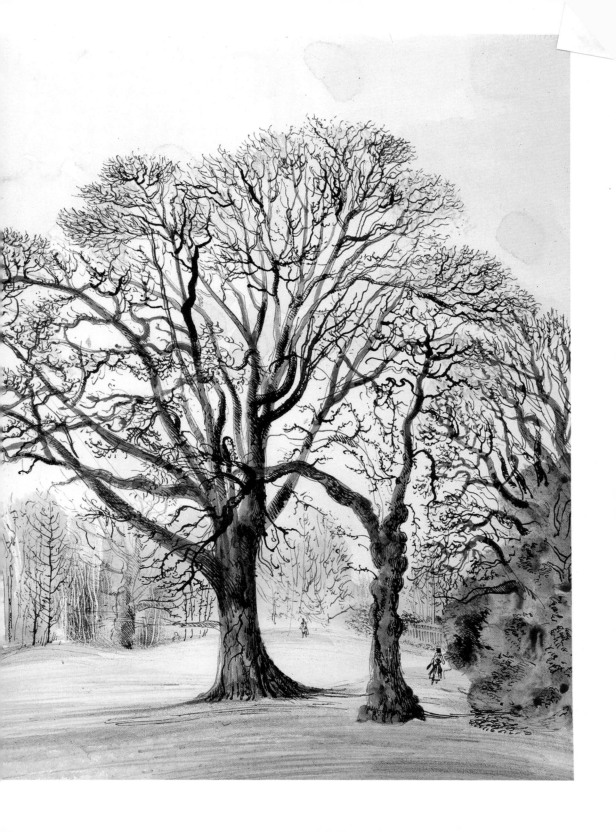

The heath is quieter on weekdays than at week-
ends, though not necessarily preferable, people
being part of its interest – kite-flying, running,
walking dogs, playing games, sitting on benches
stretching out on the grass when its hot – and
usually talking. There are many old or fallen trees
and the heath's ecological approach to their con-
servation leaves them to disintegrate at their own
pace, which makes them much more interesting
to draw than if they had been chopped neatly up
and the bits taken away.

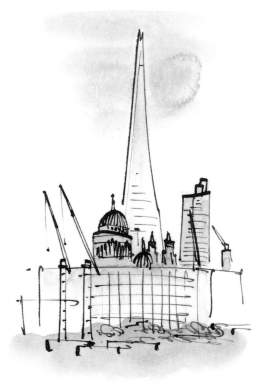

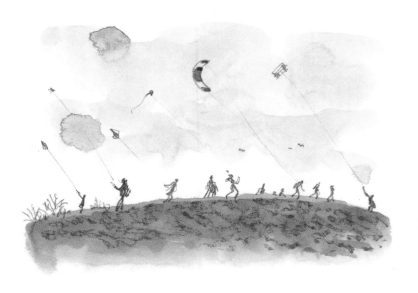

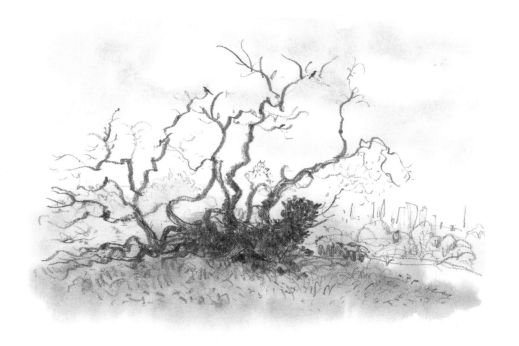

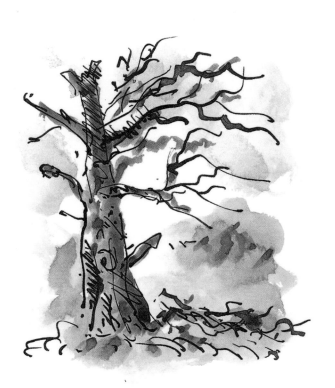

Top: Fallen tree near
Kenwood, 2018

Bottom: Standing tree
in Kenwood, 2018

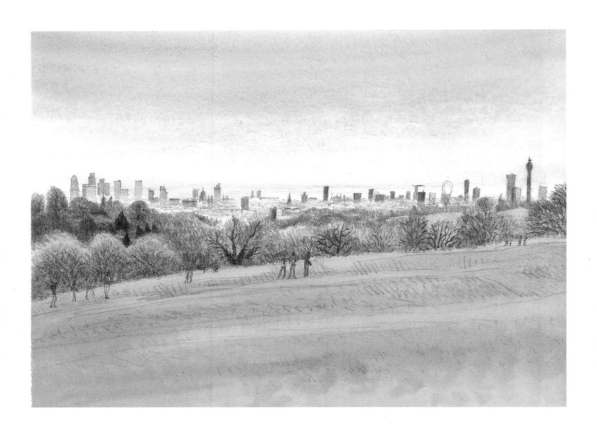

Hampstead Heath in March, c. 2006

Heath

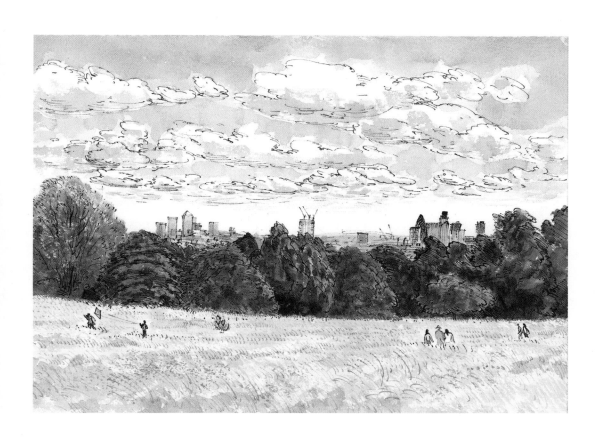

Hampstead Heath in August, c. 2007

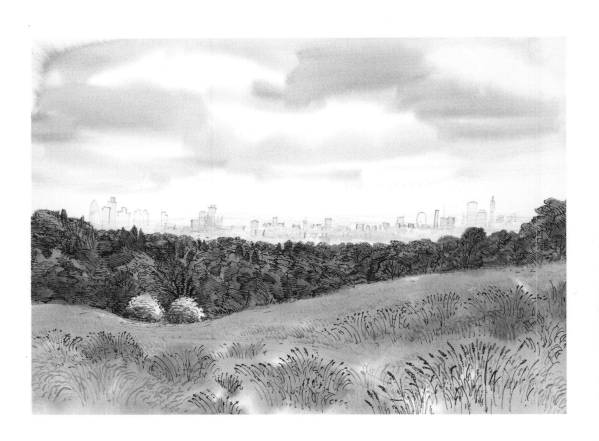

Hampstead Heath in July, c. 2006

Heath

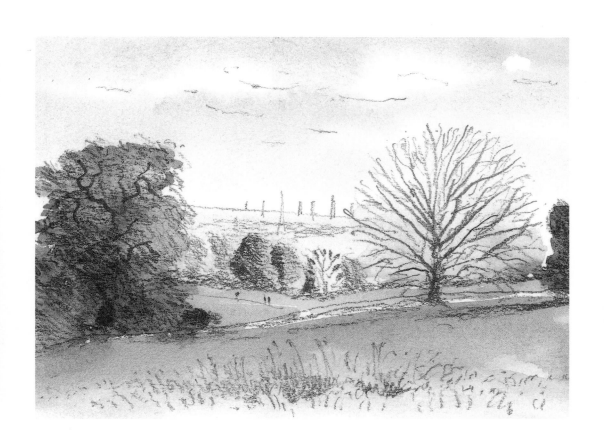

Hampstead Heath in October, 2018

The heath's most memorable subjects are its views of the City, appearing beyond its own contours, hummocks and depths, and the skies themselves, with or without kites. These wonderful skies remind me of Suffolk landscapes and of Constable. Being able to sketch a landscape used to be a required skill for young army officers. Walking on the heath is more energetic than strolling in the park with the interplay of people, the immediate surroundings and the background, the snatches of unbuttoned conversations you can't help overhearing. I also like the heath's own sounds: the seagulls, swans, cygnets, ducks, moorhens and coots on the streams and ponds, the crows and jays and magpies. The noisiest and most visible are the flocks of green parakeets – there were none there when I first got to know it.

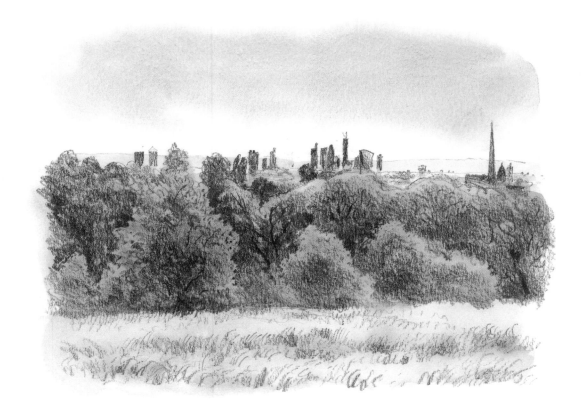

The City from the edge of Kenwood, 2018

The Heath in winter, 2018

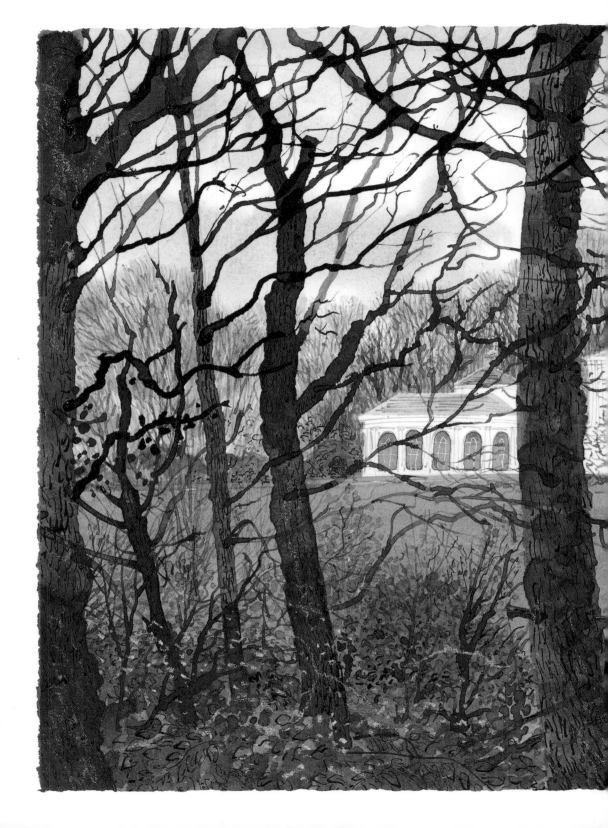

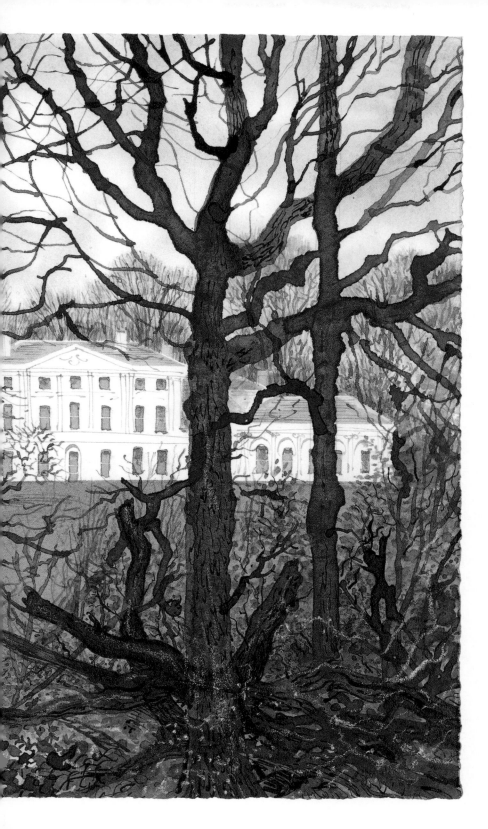

Part Two

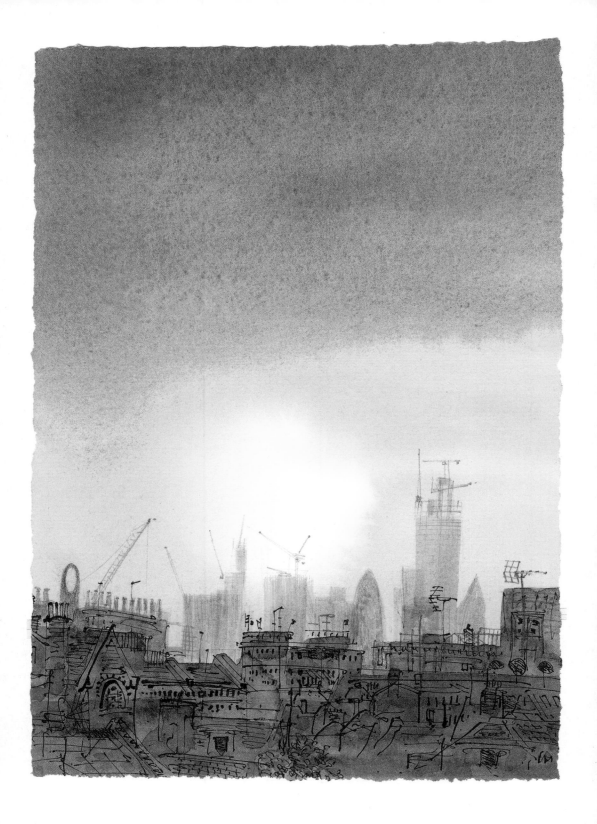

Studio

While the city around it has been steadily if stealthily transforming, my studio and working life have hardly changed since 1970, when we moved across the crescent in Camden Town to a terrace house with a well-lit and undisturbed top floor. Each morning after breakfast my commute is simply up four flights of stairs, to a studio where I can draw from the windows or finish work begun elsewhere, think, work ideas out, reflect, and decide what to do next. When we're away from home, this is the room I most miss.

From my desk I look out on trees – the leaves of the silver birch waving wildly in the wind and the birds that feed and perch there; our neighbours' slate roofs, the creepers on their walls and the magpies and pigeons on their aerials; wood-pigeons and collared doves, jays and magpies and noisy parakeets; blue-tits and goldfinches that feed in the upper foliage and wrens that nest in our wooden nesting box, even an occasional heron. Peering to the right, beyond the aerials and the remaining chimney-pots of Camden, lie the tall buildings of the City and the spidery cranes rising above them. Apart from these, not much has changed in the distance from the studio, though new structures now hide the Caledonian Market tower, the trees on the Heath and Primrose Hill, and the Dutch-gabled roof of our children's first school.

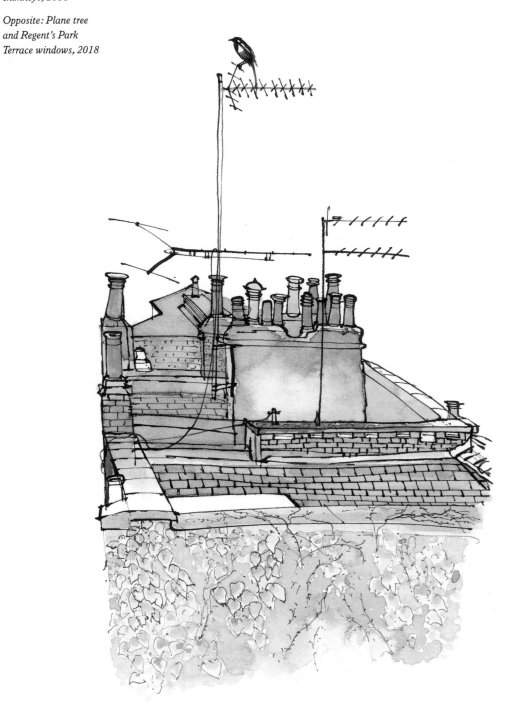

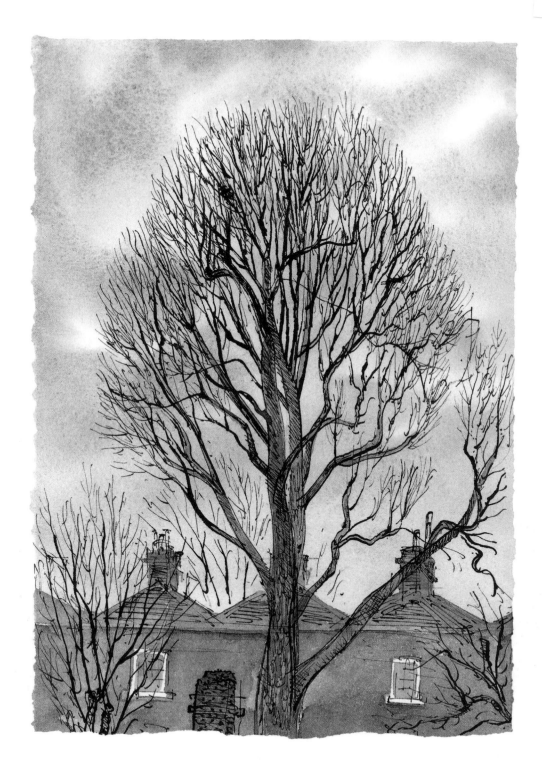

Winter sunset, 2018

Studio

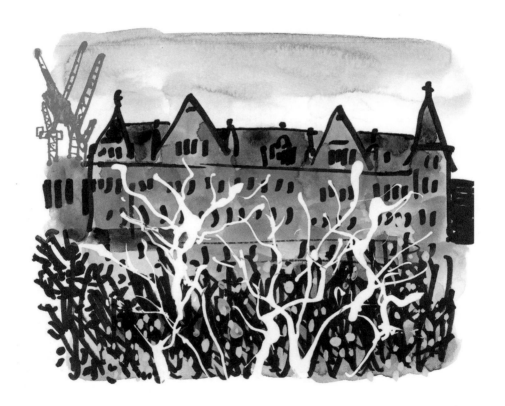

Arlington House, 2017

The view from my desk in November. The branches of the silver birch were drawn first with the tip of a candle, sharpened as if it were a crayon, so that it would repel watercolour when afterwards it was painted as a wash over the trees.

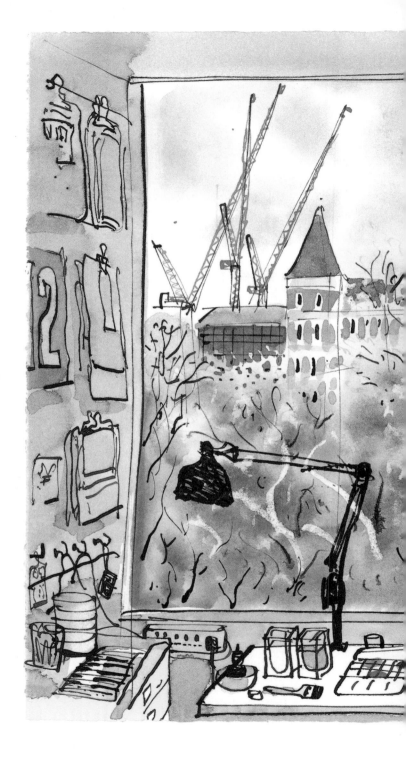

The view from my studio with pinboards to either side, 2018

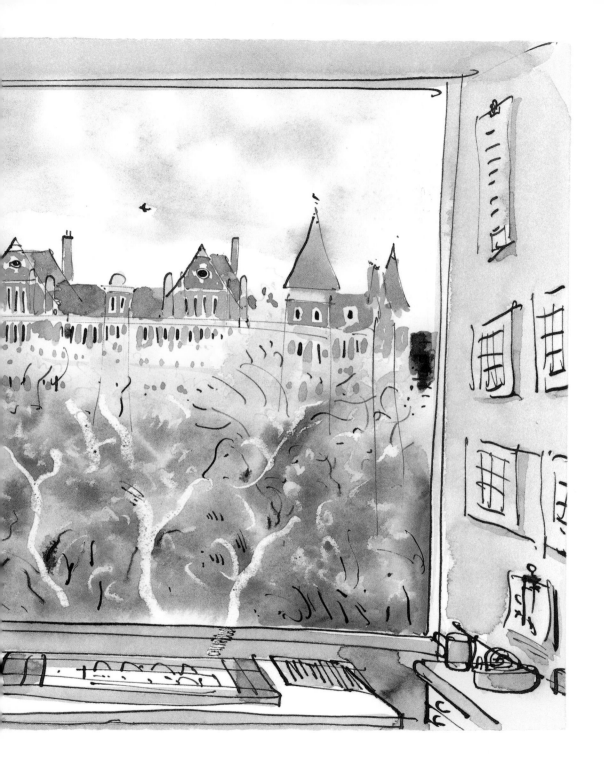

In the studio itself are a big working desk that can tilt if necessary, surrounded by the things I need most often: paints, a lifetime's accumulation of watercolour brushes plus a few really new ones, watercolour boxes and pens and pencils and an old-fashioned pencil sharpener, the phone, a pocket camera and a computer on which I can look at photos and arrange page layouts and write (but not yet draw). At the other side of the room are more pinboards, plan chests and filing cabinets, a sink, two more windows, a whole-wall bookcase full of books and old sketchbooks and solander boxes for archives, and our cat's Ikea chair.

Victorian proofing press, old lithographic stone and studio essentials, 2018

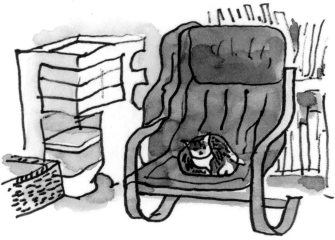

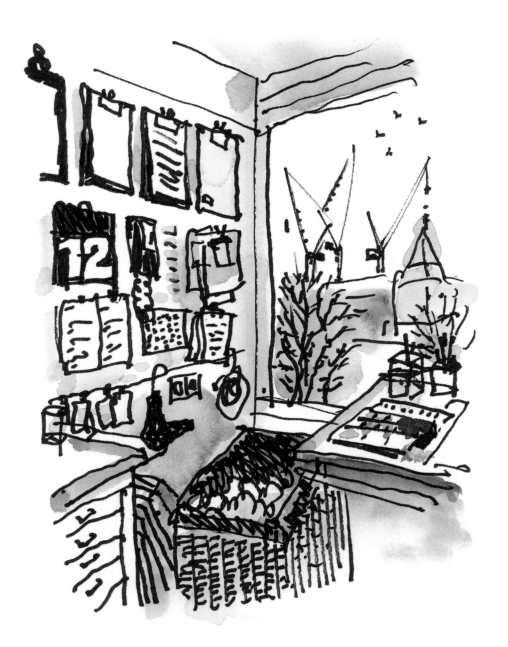

Studio

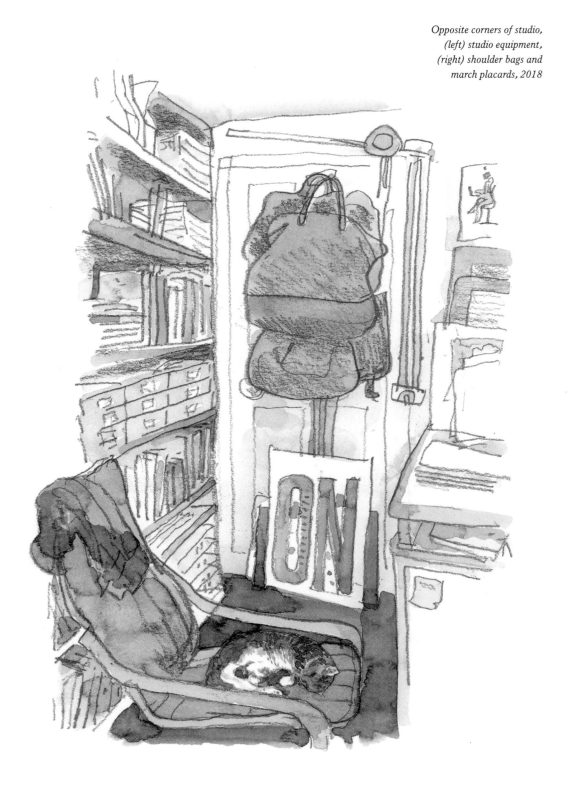

*Opposite corners of studio,
(left) studio equipment,
(right) shoulder bags and
march placards, 2018*

ON

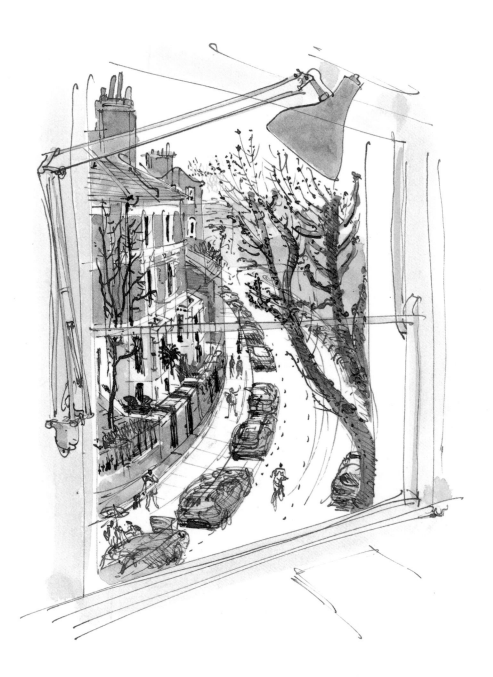

Studio

Kitchen table and front yard, 2018

The garden at the back, visited now and then by
foxes, has a tall silver birch tree which we planted
as a sapling nearly fifty years ago, plus many
plants in pots and a garden bench that in summer
gets three hours' sun during which we can sit
with our cat and have a mid-morning cup of tea.

Back garden, 2019

Back garden details, 2018

Back garden white beam tree
and Arlington House, 2018

Our neighbours' spring
ceanothus blossoms, 2018

High Street

When I first came here I was too busy with commissions and deadlines to draw Camden High Street, until the need for a Christmas card impelled me to engrave one of the local fruit-barrows. The street rose to fame as a busy stretch of small, friendly and individually run shops with traditional facades, but it is now a more anonymous shopping street that has seen better days. But a few splendid remnants are still standing: Britannia Junction, Camden Town's central crossroads, is a vibrant traffic-filled open space surrounded by banks and what used to be pubs, and on the pavements by visitors, dealers, buskers, beggars and people sleeping rough. At Camden High Street's southern end one of the old Edwardian theatres and music-halls is flourishing as Koko, a dance venue. Almost out of sight beyond the Mornington Crescent tube station is a corner of Greater London House, previously Carreras' cigarette factory; behind that but invisible from the main street is the beautifully curving Mornington Crescent itself. Apart from the architectural mix, the most tempting things to draw on this street are the people: young, cheerful, wildly dressed and, like the stallholders themselves, cosmopolitan and polyglot.

Vanished shopfronts in the Camden High
Street and Hampstead Road; the first have been
tidied up, the second demolished. Nearby there
used to be an art materials shop, handy for the
Euston Road artists and the Slade students.

*Top: Camden High
Street, 1984*

*Bottom: Hampstead
Road, 1984*

The name of the Dublin Castle reflects
the immigrant labourers who dug the
canal and the railway cuttings.

The Dublin Castle in
Parkway, 2019

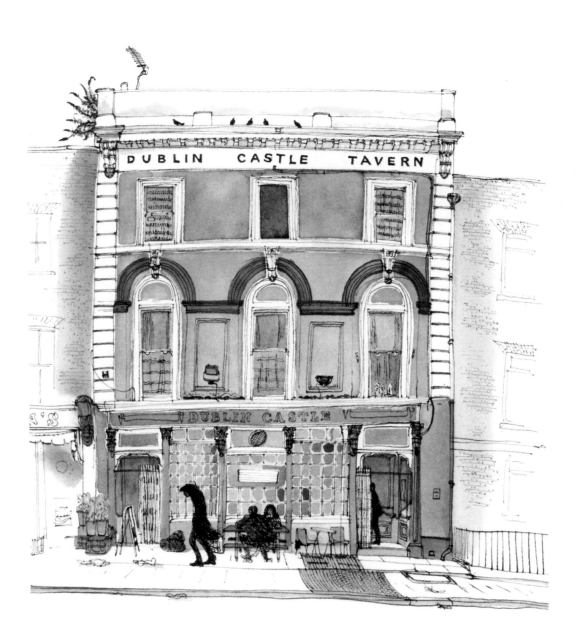

Top: Jeweller's shop,
Camden High Street, 2018

Bottom: Ex-petshop,
now a bakers' shop and
cafe, Parkway, 2019

Britannia Junction is an open space for per-forming, hanging around and meeting people in, and a bus and tube intersection where six roads meet. Strange but popular square wooden benches have been added since I drew it, good for chatting on and for keeping cars off the pavement.

The more recent newcomers – chain stores, supermarkets – have their own familiar brand shopfront fascias at ground-floor level but above this most of them put up with non-descript existing facades, and some are now becoming being victims of online shopping and closing down.

Britannia Junction, 2018

Six intersecting roads, each with its own vistas
and vanishing points and different in character,
and good seen from the top of a bus.

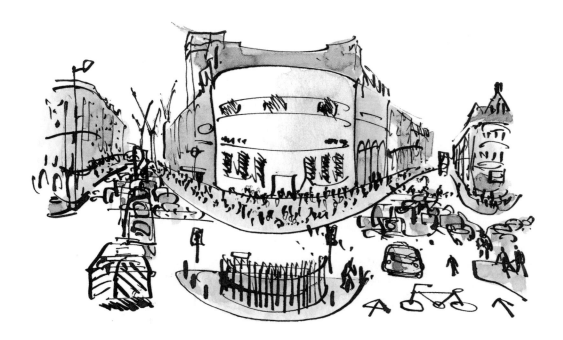

Britannia Junction,
looking north-west and north, 2018

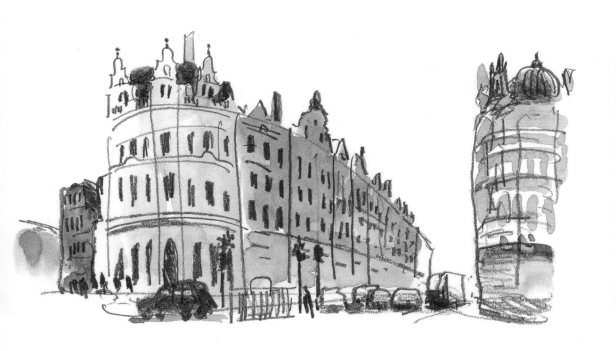

Britannia Junction,
looking south-east, 2019

Saxophonist and
accordianist, clowns

Buskers come out in force on Saturdays and
Sundays – professional, well costumed and
friendly to the audiences that cluster round
them. Their activity is a good subject because
it's both interesting and repetitive.

Mad Hatter's tea party,
dragon, horn player

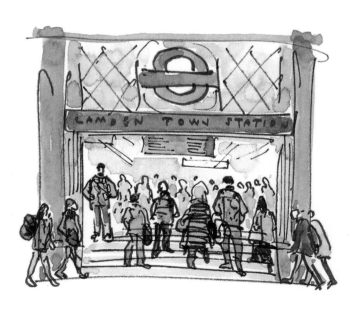

Top: Camden High Street, Bowman's ex-furnishing emporium, 2018

Bottom: Camden Town tube station's entrance on Kentish Town Road, 2019

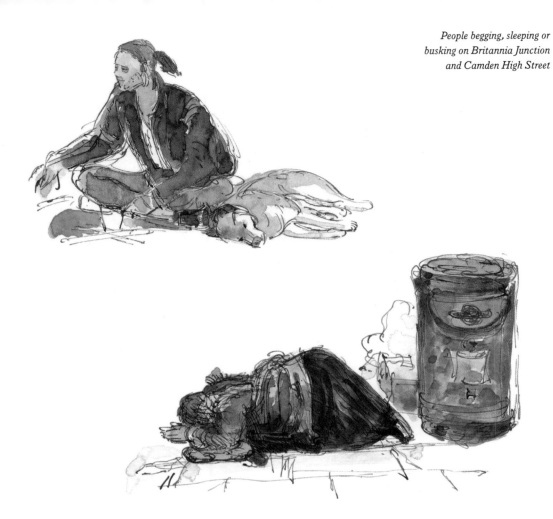

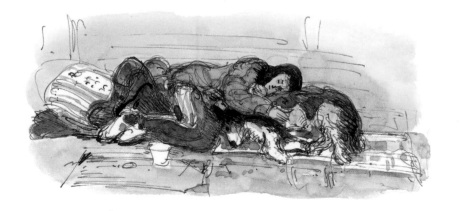

On the High Street, people sleeping rough
are shocking presences as soon as you leave
the Underground. Passers-by intent on their
errands are too busy to notice or mind or
stop for those who are begging or busking
around them. The determined man who
patiently chalks his own thoughts on the
pavement is unmistakeable and hard at work;
the others are just there, waiting.

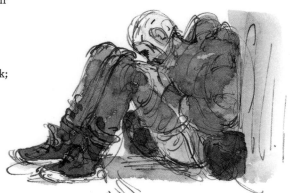

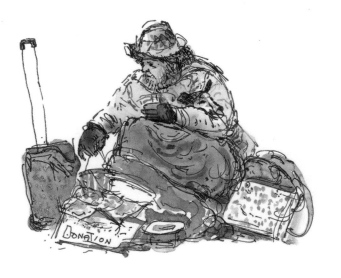

Crowds moving about are fascinating but difficult to capture on paper. Usually there's no time to draw them carefully, but having to jot down figures running past before they vanish can help even a scribble to look vivid and real, as if it had been drawn in a sort of shorthand. Including people gives scale to a scene, and drawing attitudes, clothes and movements can give life to it. Character is interesting, caricature isn't.

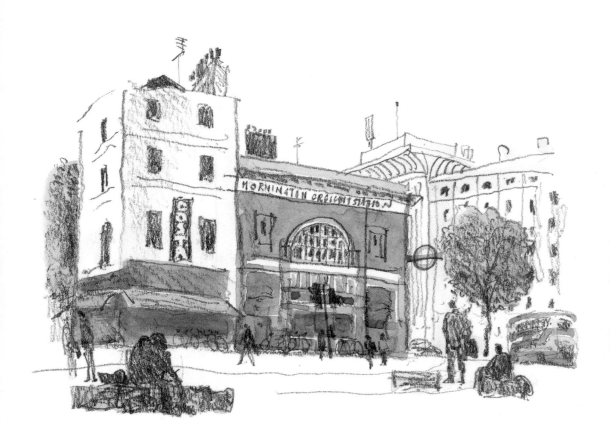

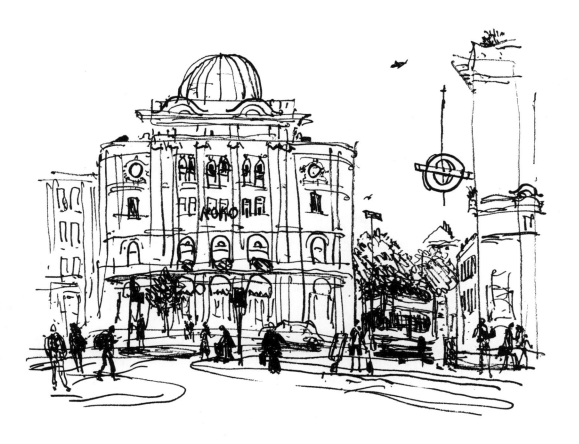

Camden High Street ends at
Mornington Crescent, 2018

Carreras' cigarette factory, a handsome art deco building of the late twenties and a monument to a profitable if deadly product. Its facade is in Egyptian Revival style; now it houses offices and amenities. It was built on a public garden, obliterating the views of and from the real Mornington Crescent that survives just behind it. This crescent was home to Dickens and the Camden Town Group of painters, Sickert, Gilman and Spencer Gore, and Auerbach's studio is nearby.

High Street

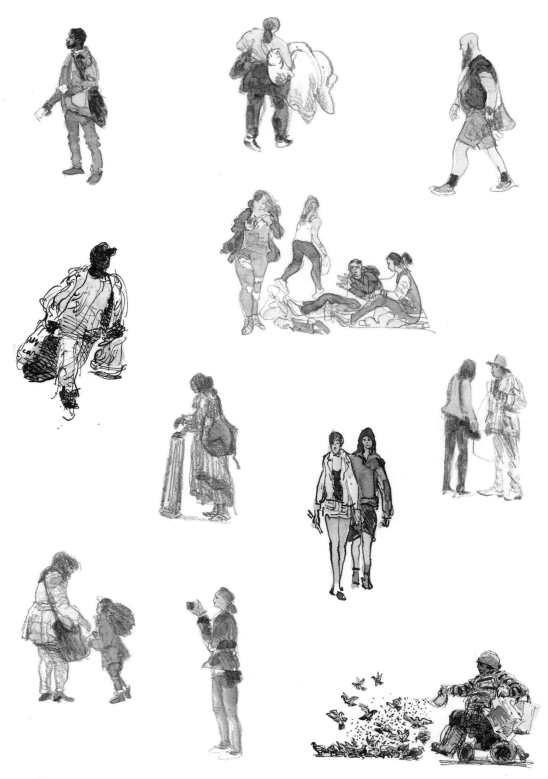

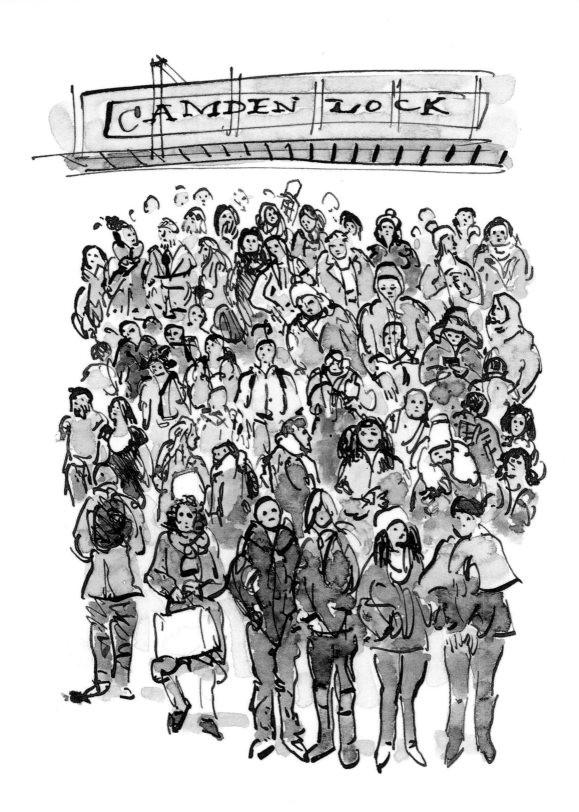

Markets

Camden's street markets are its main local industry and tourist attraction. When I first moved here, the nearest market on Inverness Street was set between shops that were low-key but vibrant and individual – a Cypriot grocer, an Italian dairy, a fish-and-chip shop, a pub, a cheap but useful stationery and odds-and-ends shop. The street itself was filled in the daytime by fruit and vegetable barrows, several of each, run by Londoners. I loved drawing the old market because of its vitality, friendliness and character, and because its customers looked interesting and varied. But in the end, about ten years ago, the old market lost out to the new supermarkets. It was replaced by a different kind of market altogether, announced by a prominent but superfluous name-plate suspended between two street lamps across the High Street end, rebranding it as a tourist attraction. But irritating or even deplorable developments still make good subjects – you needn't like what you draw.

The more famous Stables Market occupies what had previously been the Camden Goods Depot of the Midland railway and the site for Gilbey's Gin's warehouses. These have now become flats and media companies' HQs, but relics of earlier local industries – piano factories, a publishing house, a design office – still survive. Recent commercial developments include the space just north of the canal, 'new Croydon' to its detractors. More romantically, Stables Market has preserved the surviving tunnels, ramps, vaults and canal bridges that were created for the old goods yards' hundreds of heavy horses.

In the sixties Inverness Street market was still based on barrows and trolleys, patient queues and friendly relations between salespeople and local customers, the latter shabby by today's standards. Apart from the fruit and veg barrows like the one in the wood engraving below, the market's main attraction was a junk stall, a one-man outfit run by the no-haggling Reg Stone, taciturn in his flat cap, likened by the writer David Thomson to the captain of a tramp ship. His stock varied in its appeal: some of it dull or depressing rubbish, some it useful or lovely. It must all have been acquired by clearing out people's homes after they had died. When Reg himself died, his own formal and well-attended funeral procession came majestically up through the market on its way to the Catholic church in Arlington Road.

Fruit barrow in Inverness
Street Market, c. 1962

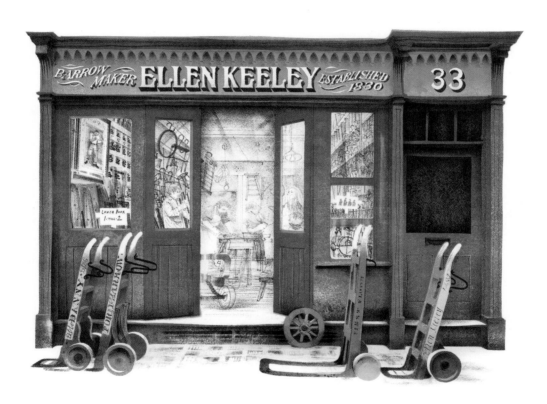

Ellen Keeley's barrow-making workshop in Neal Street, Covent Garden, lithograph, 1972

Top: Arlington Road, c. 1983

*Bottom: Inverness Street
market barrow removed to
Stables Market, 2018*

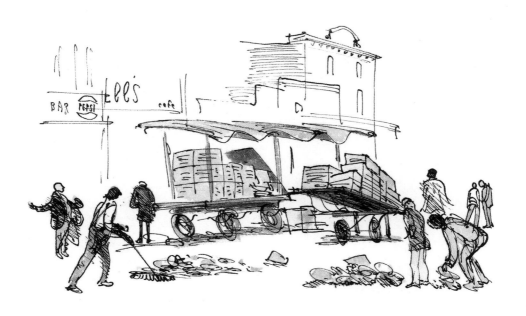

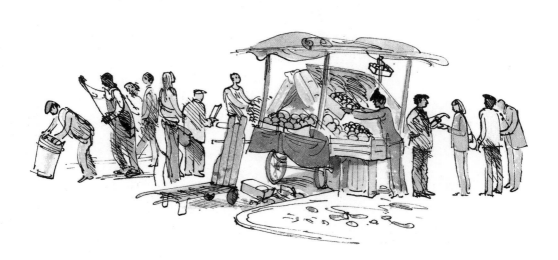

Top and bottom: Inverness
Street Market, c. 1983

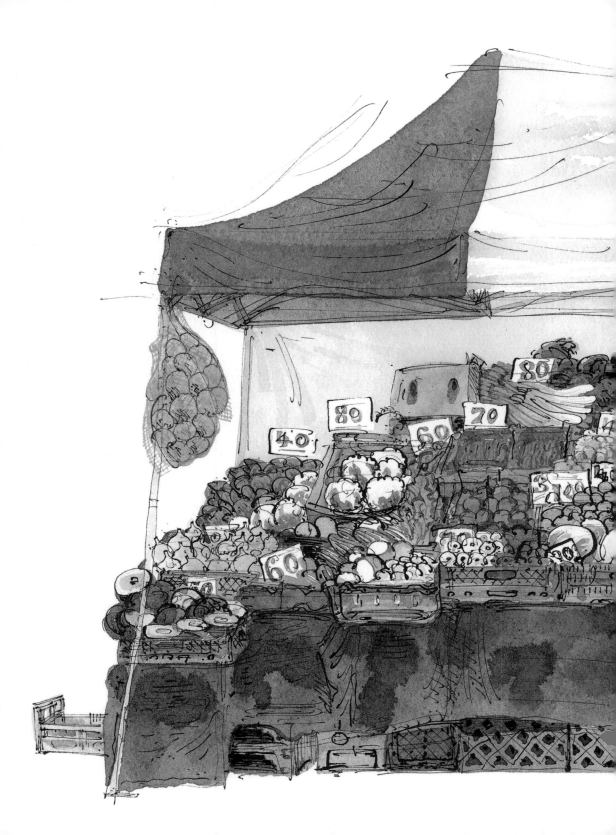

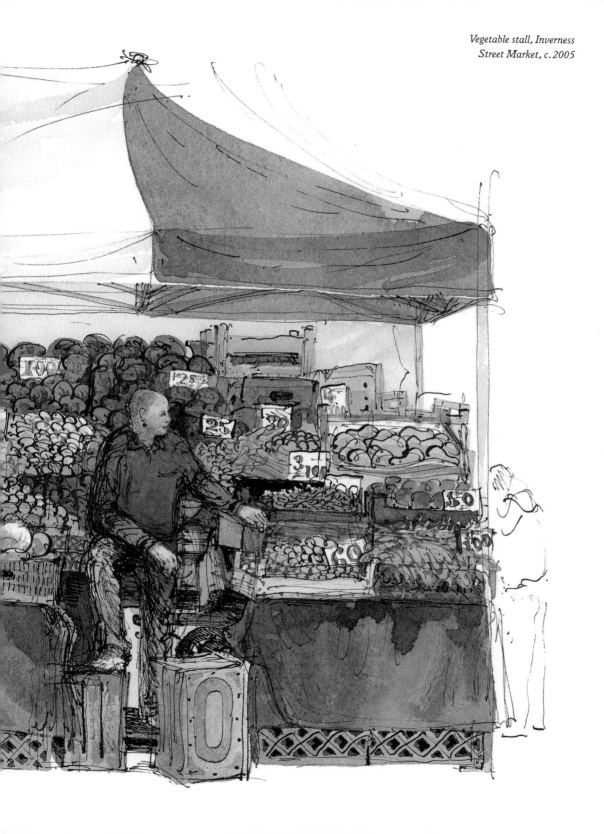

*Vegetable stall, Inverness
Street Market, c. 2005*

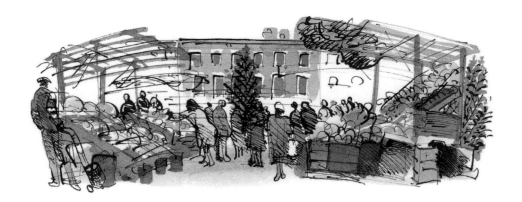

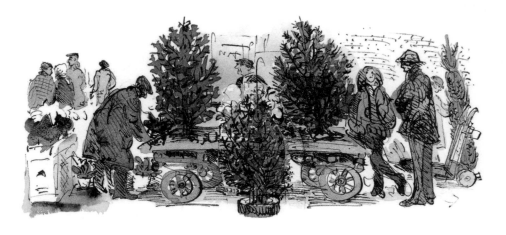

Inverness Street Market, c. 1995

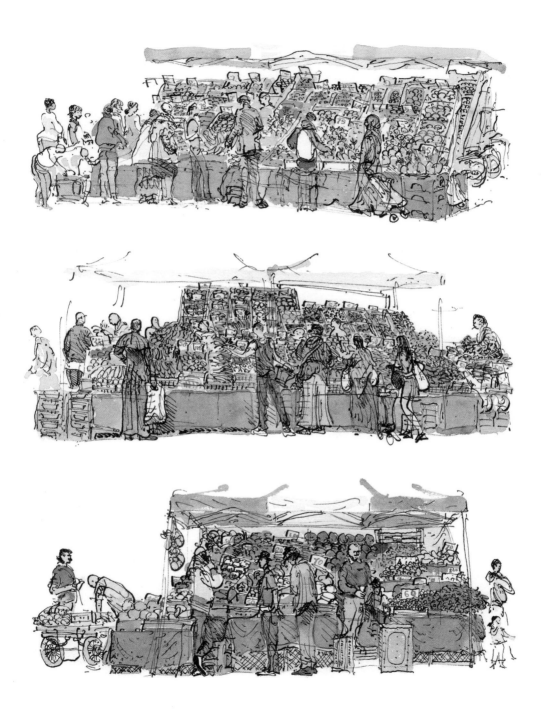

Inverness Street Market, c. 2006

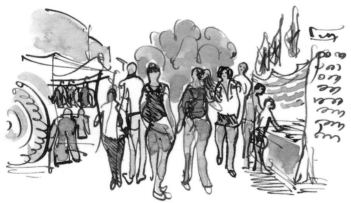

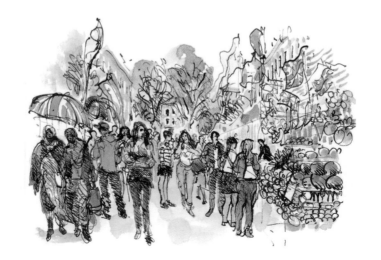

Inverness Street Market, 2018

The market is noisier now, especially when setting up at around eight in the morning; the sound of trundling barrows has changed to the clanging of metal rods as the new stalls are skilfully assembled by a cosmopolitan European-tongued workforce and their pre-arranged displays are carried from the spray-painted lorries parked nearby.

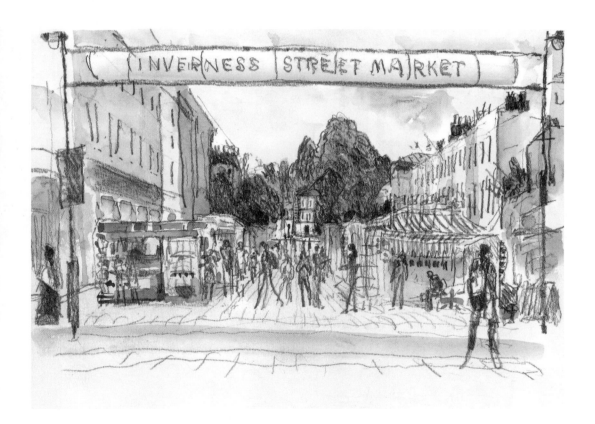

*Inverness Street from
Camden High Street, 2019*

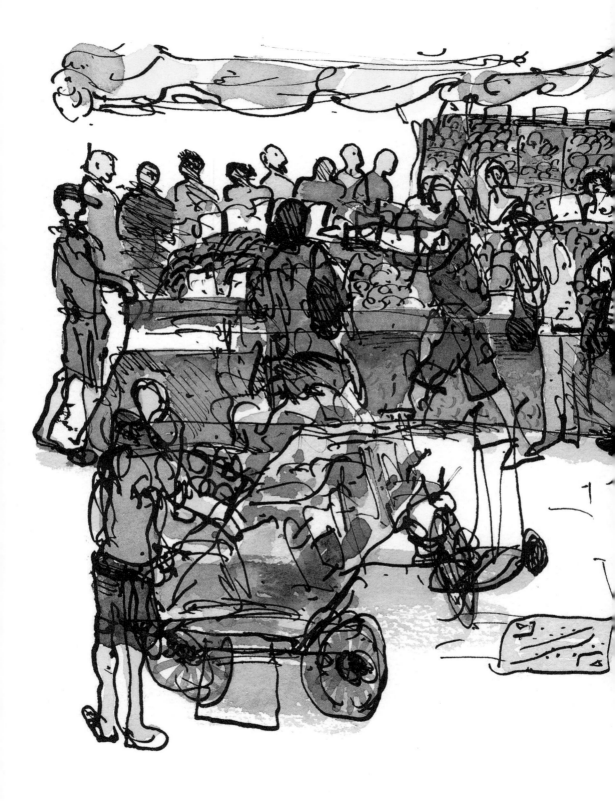

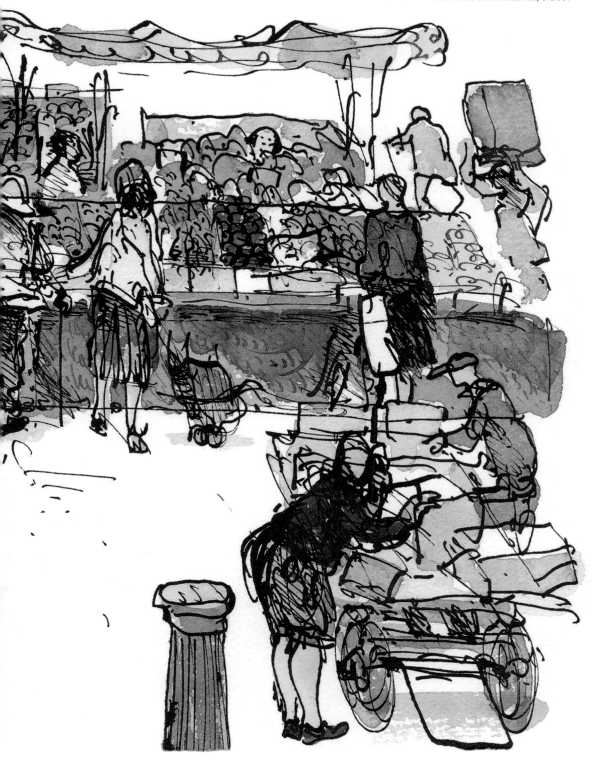

Overleaf is a quick sketch made from the top of an empty market barrow. Drawing it was tricky because the people in it were constantly changing and I had to get their activities and stances down before they moved and while I remembered them, with no time to worry about accuracy. Being up on the barrow I was out of the way; everyone was far too busy to pay any attention and they were friendly anyway. Looking at the drawing now reminds me vividly of the scene and the individuals in a way that a photograph wouldn't.

In Inverness Street Market, the fresh fruit and veg have been replaced by Union Jacks and T-shirts with red double-deckers and football teams' colours. Things get more interesting on Camden High Street; heading towards the canal, most of the upper floors have become hoardings, often ingeniously constructed, for the ground-floor businesses beneath them. Just up this road is the Chalk Farm Road entrance to Stables Market, part of Camden Market but far bigger, busier and free from traffic.

Top right and bottom:
Inverness Street Market, 2018

Top left: Camden High Street, 2018

Markets

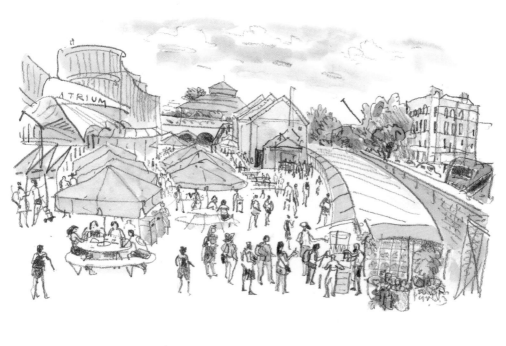

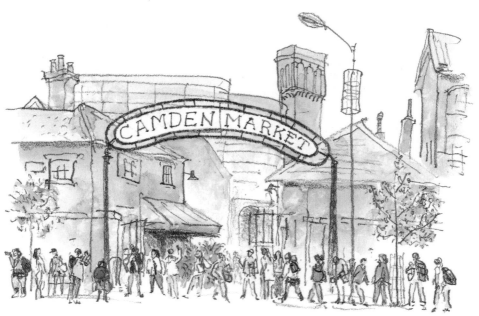

Top: Stables Market, 2018

*Bottom: Chalk Farm Road
entrance to Stables Market, 2018*

Running right through the middle of the market is the North London Railway, carrying its steady flow of freight containers on the overhead arches. (Its freight used on Thursdays in the 2000s to carry nuclear waste on its way to Sellafield.) The lock's old involvement with horses, and in particular the beautifully curving and cobbled ramp leading up to the old horse hospital, has been carefully preserved. There are other more human figures like the big bronze one of Shaka Zulu over its restaurant, and the many good sculptures of accurately portrayed horses provide a realistic foil to the imaginary creatures glittering on the wall. At the top of the horse ramp is a bridge with a good view down the main central length of the market, a subject which I've drawn many times.

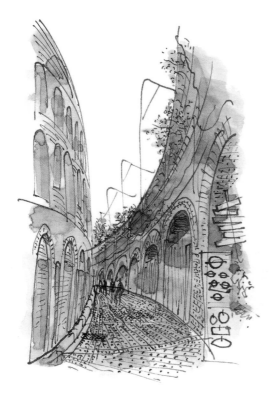

Stables Market: railway arches, 2018

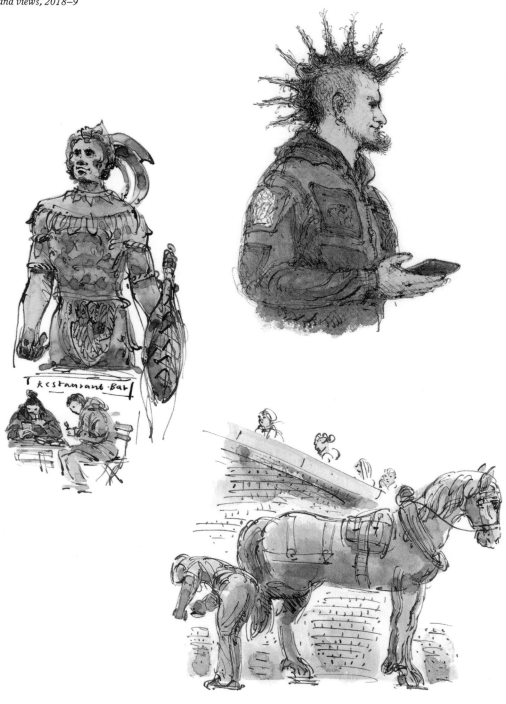

Restaurant Bar

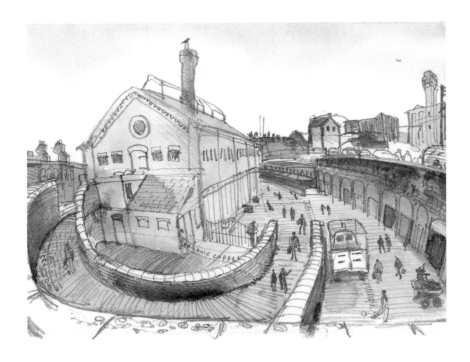

Stables Market: horse hospital and ramp, 2018–19

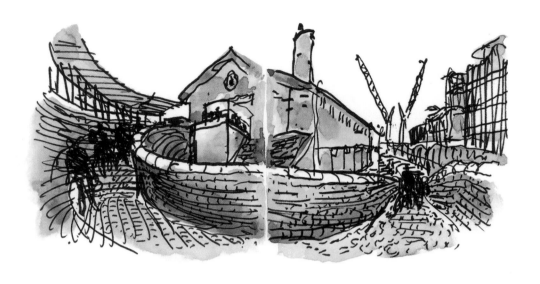

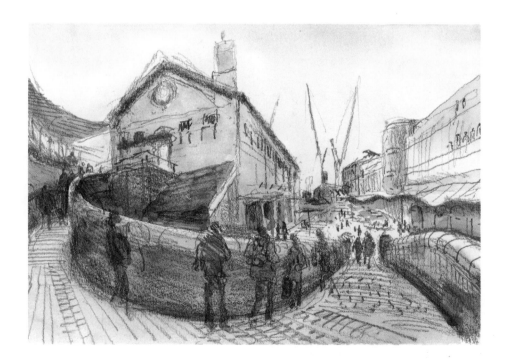

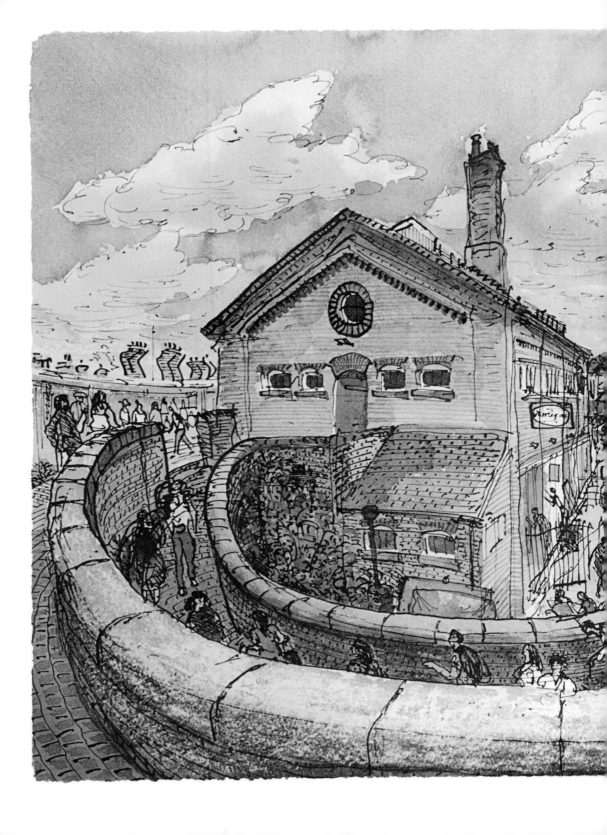

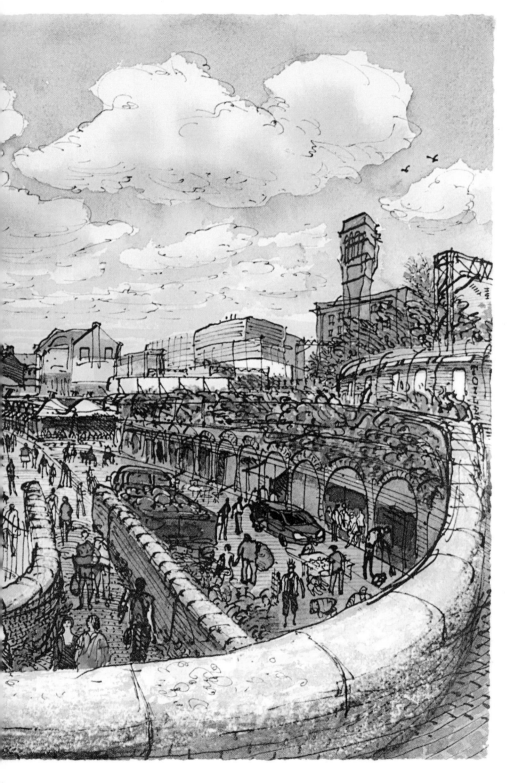

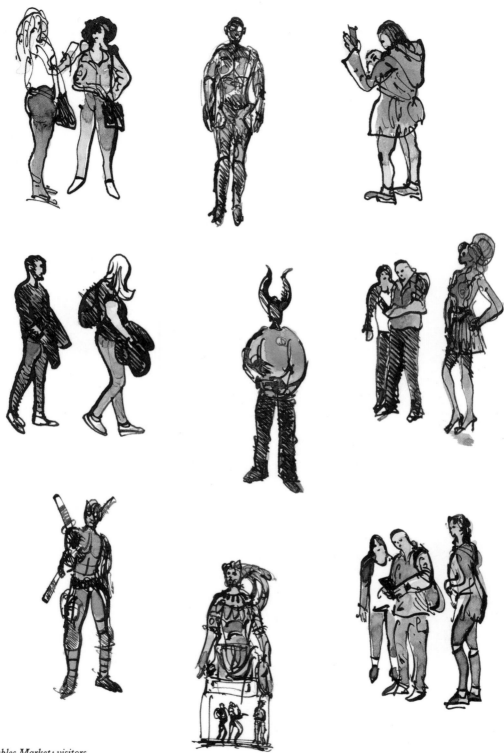

*Stables Market: visitors
and figures, 2018–19*

When drawing and painting anything, mistakes are inevitable but they needn't matter; they're just part of the process. Often they can be drawn over, or if they're serious enough you can begin again. But anxieties and uncertainty are part of the task; it's best simply to get on with it.

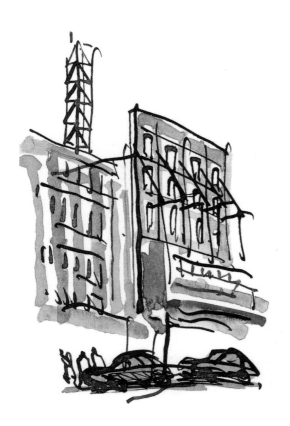

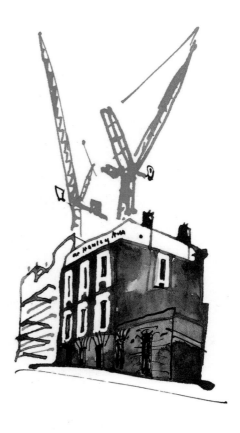

Chalk Farm Road and Castlehaven Road: reconstruction, 2018

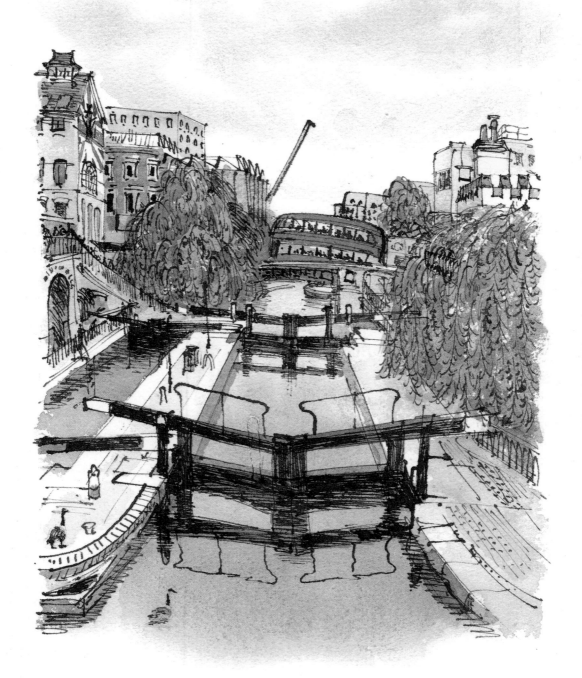

Canal I

At the edge of Stables Market lies the Regent's
Canal. It stretches westwards and upstream from a
heavily built iron bridge over Camden Lock. There
are splendid views on either side, and usually
crowds of people on both sides of the bridge
enjoying the scene and photographing themselves
and each other. I love the walk upstream from the
Lock towards Regent's Park and the Zoo, passing
the 1890s and 1930s classic modernist Gilbey
warehouses, and under the Pirate Castle Club
bridge to a stretch of the canal where children
learn how to paddle kayaks. Here its towpath has
widened out to become a sunny place to rest or
picnic on, before leading one under the main west-
coast railway line from Euston to Glasgow (along
which, earlier in my time here, steam engines
would pass constantly, depositing grains of soot
onto our window ledges). On the first-floor balcony
of one of the villas that line the canal a life-size
black-and-white cow stands motionless; from
this point on, the scene turns quickly from post-
industrial to domestic, green and rural. The most
idyllic stretch of the canal is beyond the Zoo, where
it is flanked on both sides by narrow but dense
woodland, dark and romantic, and conventionally
pretty to draw or paint.

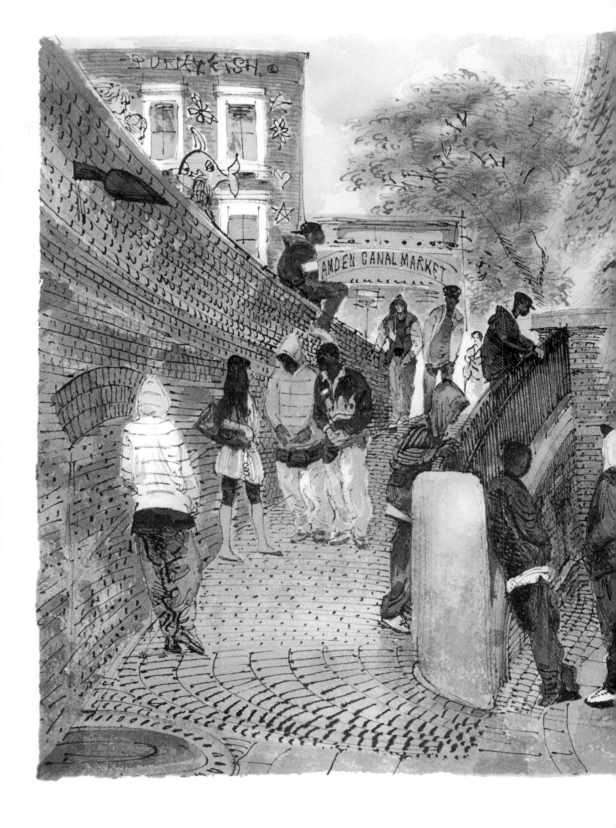

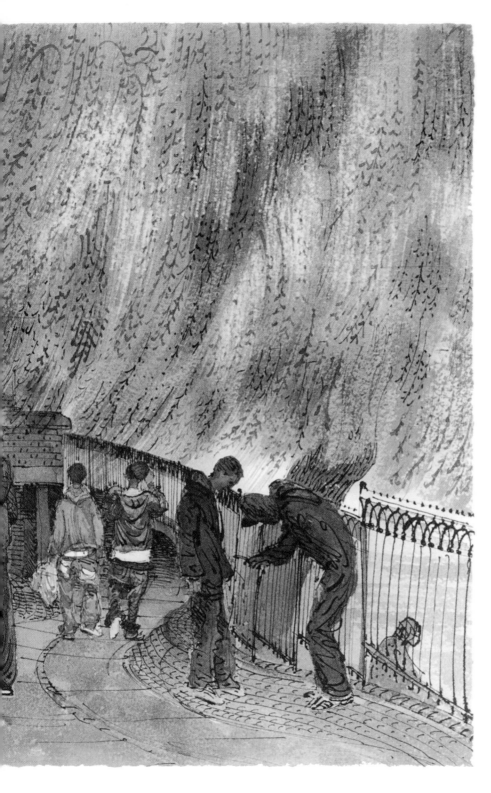

Pen-and-ink drawings of the Roving Bridge and Dingwall's Dock where Stables Market and the Regent's Canal interlink, the bridge and towpath, and people in the square where the barges dock. The dock's original purpose was to be the interchange between canal and warehouses, whereas its role now is feeding, watering and captivating today's hordes of young and international visitors. I try to draw from inaccessible or protected places – on a bench or at a café table, in a doorway or a corner or just with my back against a wall – because talking is distracting.

Camden Lock, c. 2010

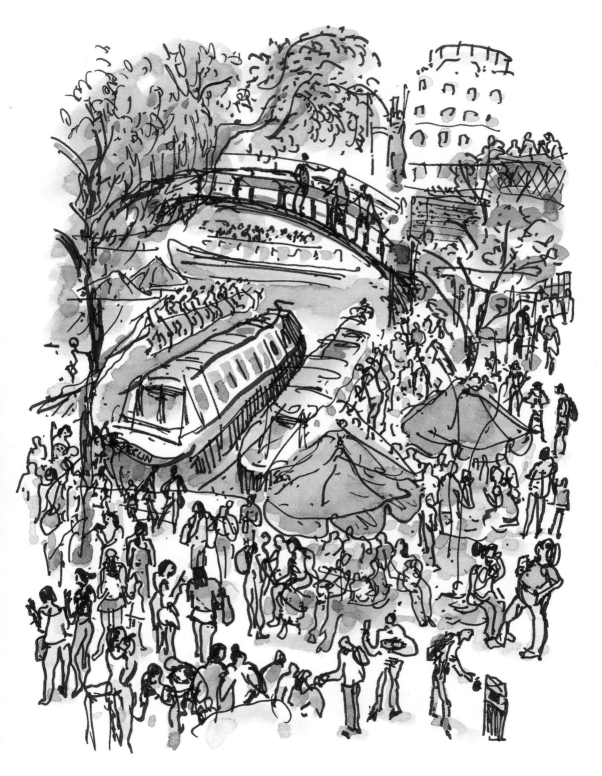

Camden Lock Place, 2018

The boats on the canal are for pleasure and for work and they're good to draw. There's the *Jenny Wren* and other regular water-buses; small drive-yourself motor-launches or boats; the canal's own maintenance craft; a punt with on-board musicians who compete with a singer with a guitar on the towpath under the railway bridge. There are kayaks and a kayaking school for children, who are adept at turning upside-down in the water and re-surfacing, and barges for living in, growing flowers on, sitting beside, and partying on the towpath.

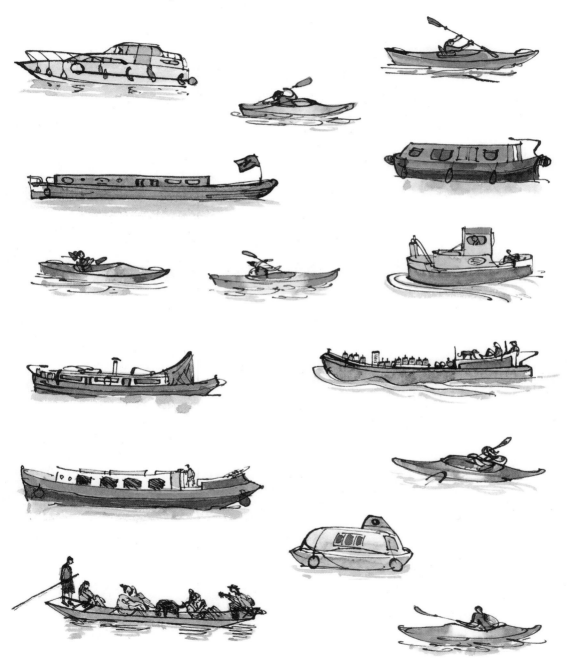

Camden Lock from the Chalk Farm Road, 2018

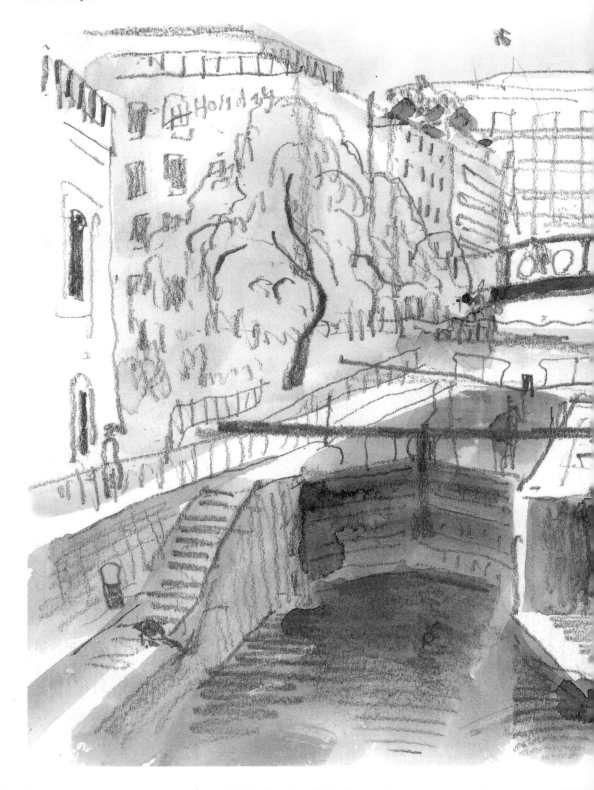

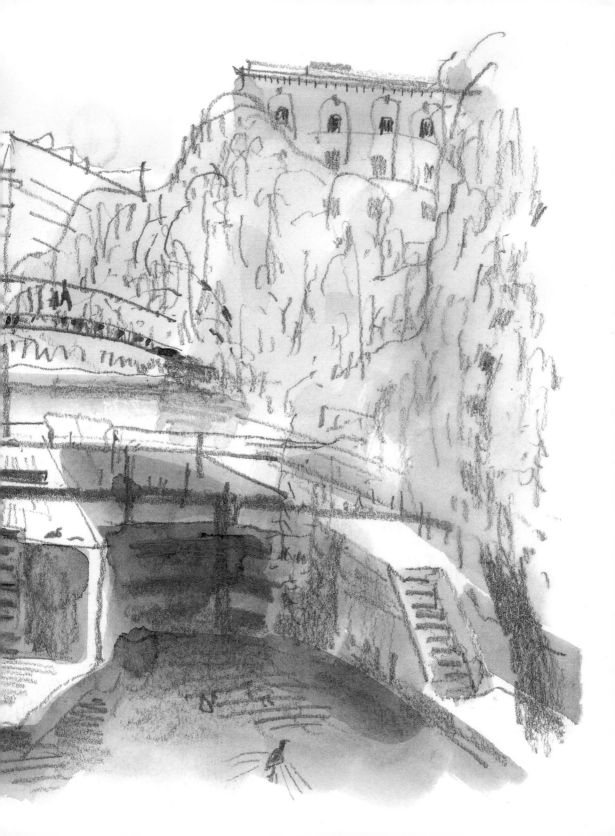

The Chalk Farm Road bridge (overleaf) remains essentially unchanged. In summer you can't see through the weeping willows' foliage; in winter you hardly notice there are trees there at all. I drew this early one morning before there were many people about. Since the twin locks are symmetrical, my viewpoint was on their central axis.

The iron footbridges that cross the canal here have shallow ramps with stone setts or cobbles, designed to keep the horses from slipping as, well into the 1950s, they pulled boatloads of goods over into what's now the Stables Market.

*Gilbey's Gin old warehouses
and the Interchange building,
now media HQs.*

*Camden Lock: interchange
building and horse
or roving bridge, 2018*

Camden Lock: horse or
roving bridge, c. 1984

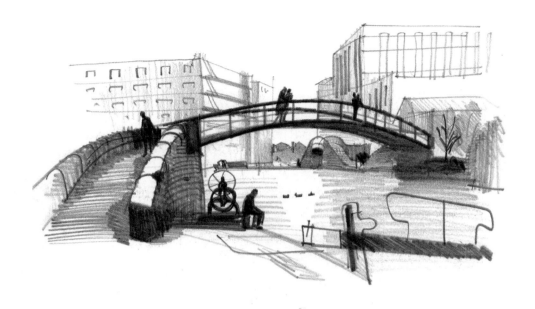

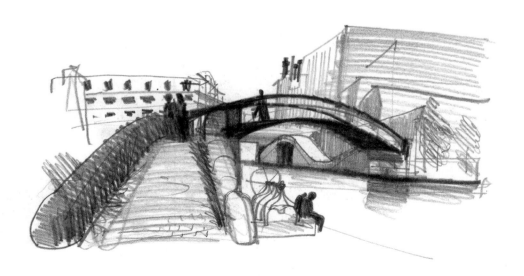

The narrow cast-iron roving bridge crossed the canal diagonally to make it longer and easier for the heavy carthorses to walk over. These pencil drawings were made about forty years ago as hurried studies for a watercolour. The lovely curves of the cast-iron were simpler and quicker to draw with a soft pencil than they would have been with a pen, and the lightness or darkness of the lines was made simply by pressing lighter or harder without even thinking about it.

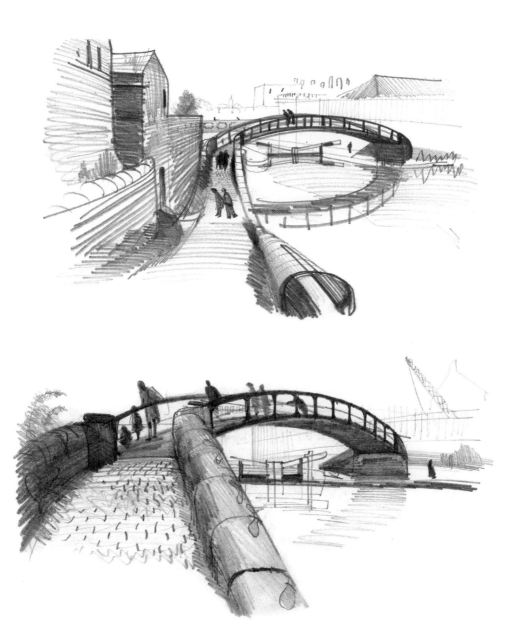

The two main features of the stretch of canal seen from the Oval Road bridge (opposite) are the Midland railway bridge, with its intrusively branded express trains continually passing through, and beyond it the Dutch gables of Primrose Hill Primary School.

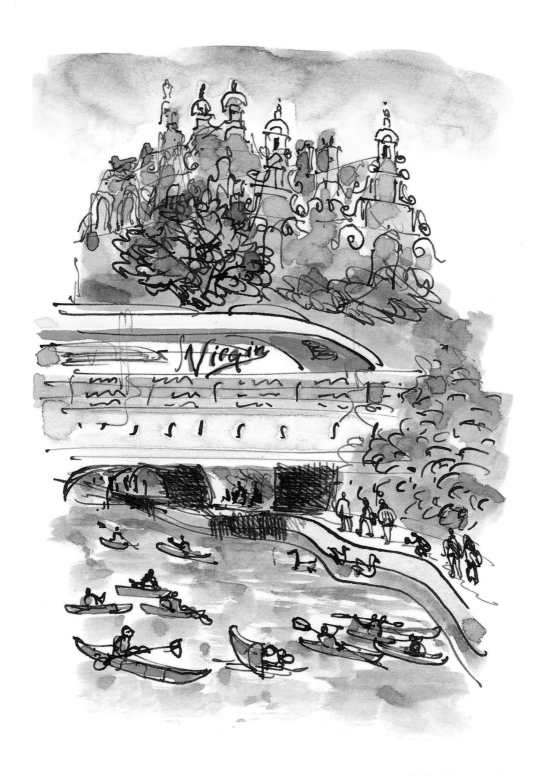

*Midland Railway bridge and
Primrose Hill Primary School, 2018*

Beside the Oval Road bridge is the Pirate Castle, a club which teaches kayaking to seemingly fearless children. Its architect – surprisingly – was Richard Seifert, who had already designed many of London's high-rises including, in 1963, Centre Point, where Tottenham Court Road crosses Oxford Street.

The kayaks haven't frightened away the ducks, geese, moorhens and coots which frequent the canal and bring up their young here. This sunny stretch of towpath widens out enough to attract groups of visitors resting after an exhausting tour of the market.

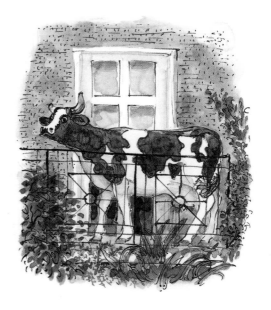

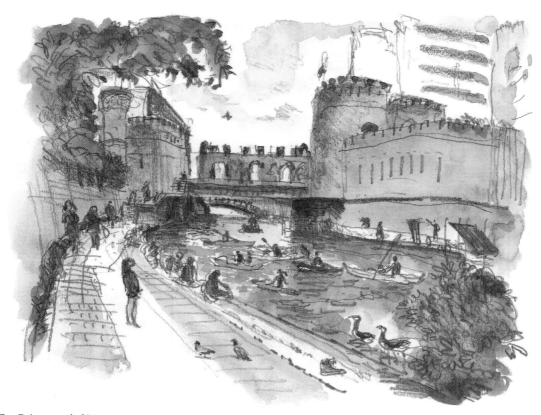

Top: Balcony overlooking the canal, 2019

Bottom: Pirate Castle, 2018

Canal I

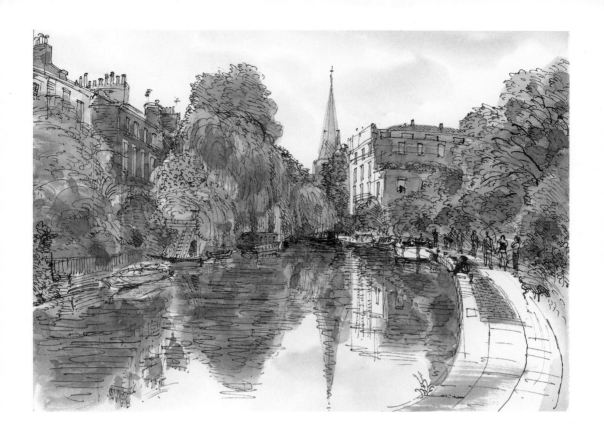

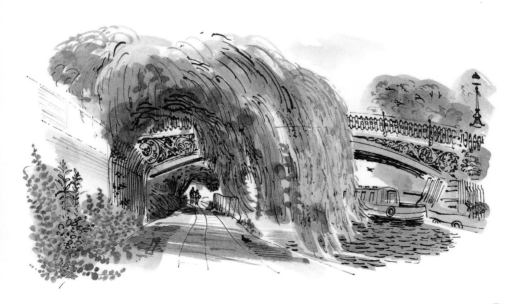

*Top: Canal towpath
with St Mark's Church, 2011*

*Bottom: Iron footbridge over towpath from
Prince Albert Road to Regent's Park, c. 2000*

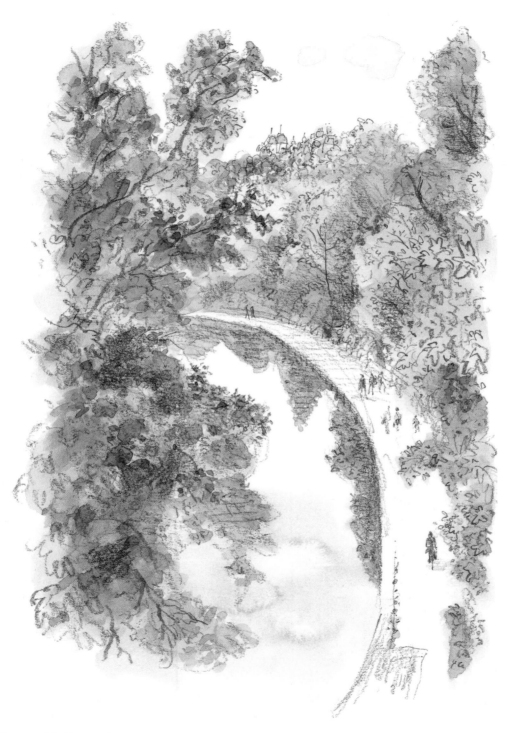

The towpath looking west from
Macclesfield or Blow-up Bridge, 2018

Canal I

At the far end of the Zoo begins the wildest and leafiest stretch of the whole canal. At its centre is Macclesfield Bridge, known locally as Blow-up Bridge, temporarily destroyed in 1874 by the explosion of a barge carrying five tons of explosives. It was rebuilt two years later using the same sturdy cast-iron Doric columns.

There is usually a steady flow of boats all along on the canal, but this part of it is at its best when they're out of sight, leaving the reflections unbroken. The narrow footpath hidden beside the towpath is at its loveliest in May when the hawthorn blossom and the cow parsley are out.

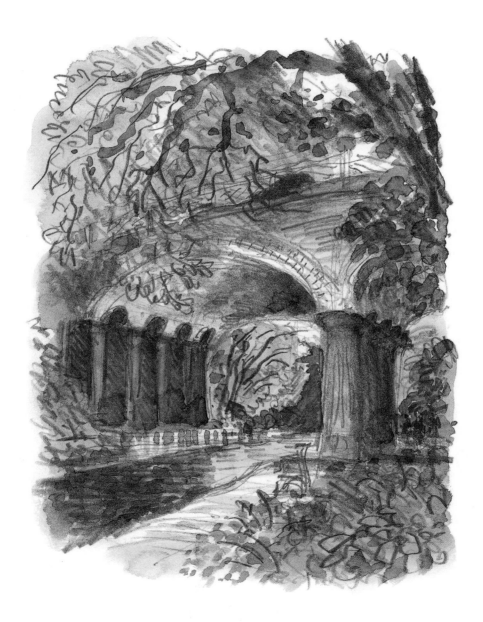

Macclesfield or Blow-up
Bridge from towpath, 2019

Railways

The railways, like the canal, are an intricate but often hidden part of Camden's past and present. As you walk along the canal towpath, the Eurostar into St Pancras rumbles invisibly overhead on big bridges, while trains into Kings Cross tunnel deep underneath it; yet in order to cross over the canal near Camden Lock, trains from low-lying Euston must climb steeply upwards in a deep cutting where they can be glimpsed only from the top decks of buses. But as well as being ingenious and dramatic-looking, the railways have also been merciless. Joining the west coast and Midlands train lines that cross through Camden is the planned High Speed 2 line, a much-debated and hated development which has already destroyed a park with many beautiful trees and is now disrupting the local roads.

As a boy in a family without a car, I was fascinated by railway engines and they were the first things I drew. My early train journeys all ended at Kings Cross, where incoming trains often had to pause in the tunnel while waiting for their platforms, though at the time I luckily never realized there was a canal overhead. Today I still love to draw trains and railways, their tunnels and their termini because of their intricate mix of design, architecture and engineering, their big confident shapes, their tantalizing different levels, their crowds of anxious passengers and their all-pervading contrasts of old and new.

Although both are made of metal and glass,
I like the architectural contrast between the
semi-circular Romanesque roofs of Lewis
Cubitt's elegant King's Cross and the essentially
medieval pointed-arch structure of the vast
single roof of George Gilbert Scott's St Pancras.

*Top: King's Cross from
Euston Road, 2018*

*Bottom: King's Cross
booking hall, 2018*

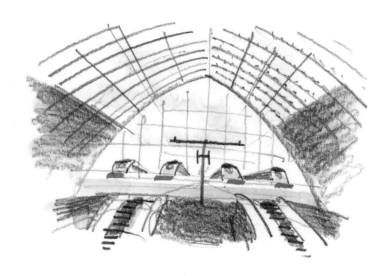

Top: King's Cross interior, 2018

Bottom: St Pancras interior, 2018

Several bridges in a disused section of the Overground line near Camden Road have been left open to the sky. I like drawing them because from underneath it's not where one expects to see any sky at all.

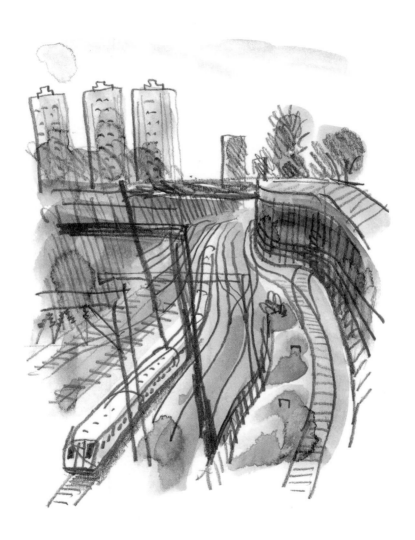

Railway cutting below
Mornington Terrace on the
Midland line from Euston, 2018

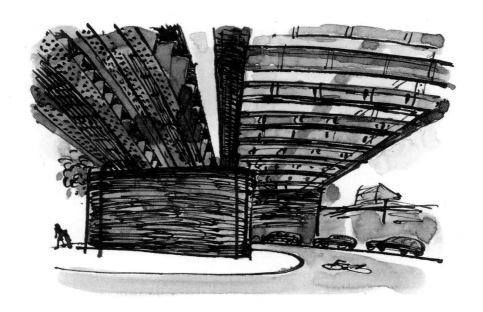

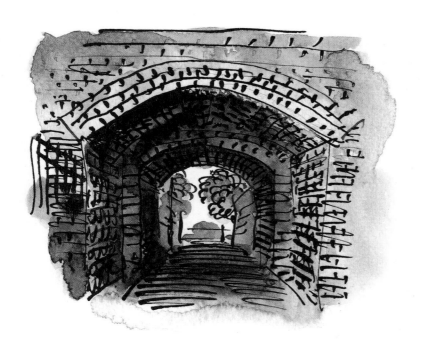

*Top: Overground bridge
and disused bridge over
Randolph Street, NW1*

*Bottom: Two adjoining bridges
over a pedestrian tunnel,
College Lane, Kentish Town, 2017*

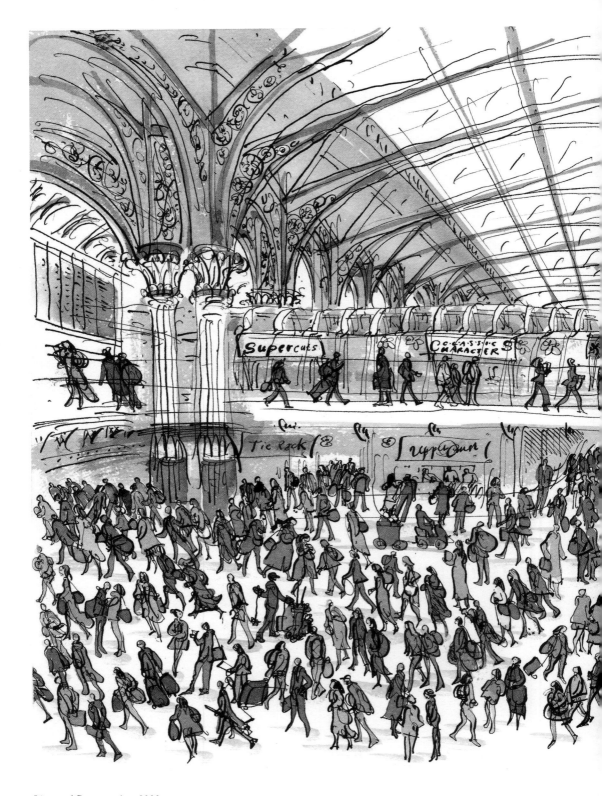

Liverpool Street station, 2000

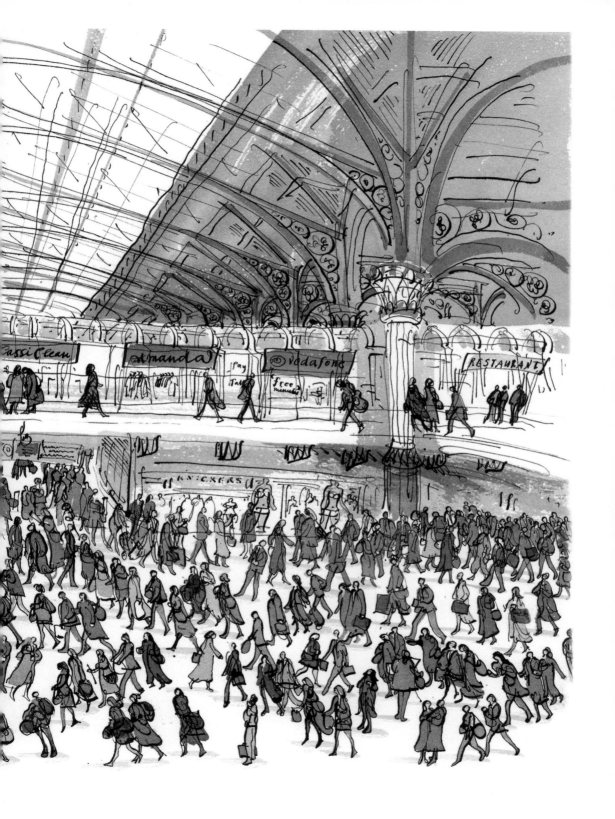

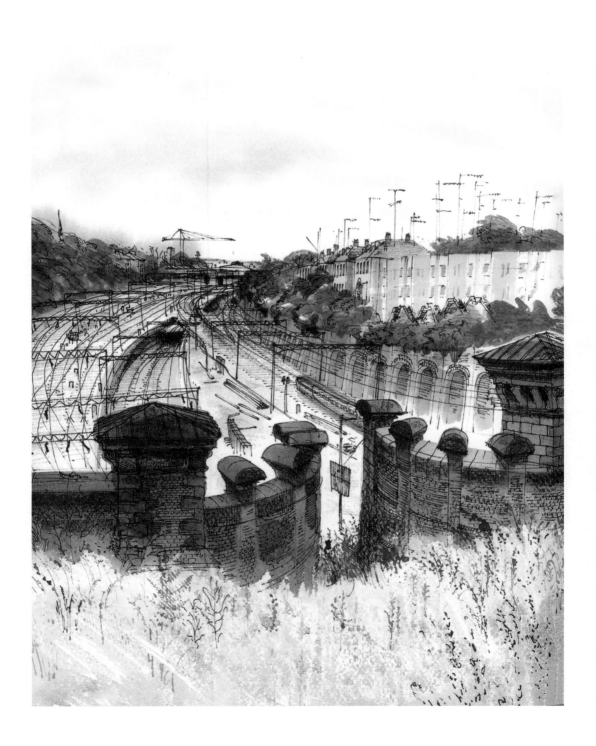

Tunnel entrances are interesting because, since they were the only feature of a tunnel that anyone could see, their architects had a chance to impress with their designs. I like the contrast between the flamboyantly show-off tunnel entrance to Chalk Farm Tunnel and the simpler, more discreet and practical one at King's Cross. Unless you happen to live next to the amazing Chalk Farm entrance drawn here like a stage-set seen from behind, it's now hidden behind flats, but you can still just get a sidelong glimpse of it through foliage and nettles where Primrose Hill Road and King Henry's Road cross. The King's Cross tunnel (detail below) is the one I used as a boy to sit in while my train from Hertford waited for a platform.

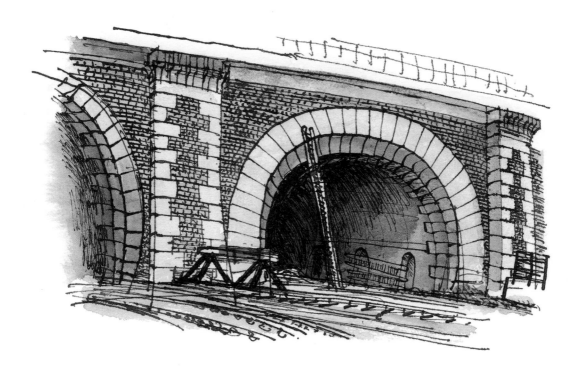

Opposite: Chalk Farm tunnel entrance, 1984

Above: Tunnel entrances at King's Cross, 2018

The heedless consequences of the controversial High Speed 2 line have included the felling of ancient plane trees during the destruction of the St James's Gardens, the small but beautiful park next to Euston station which was a once historic burial ground. From the Hampstead Road you can see, above the PR hoardings, the destruction of green spaces and general devastation caused by a railway line which may never materialize.

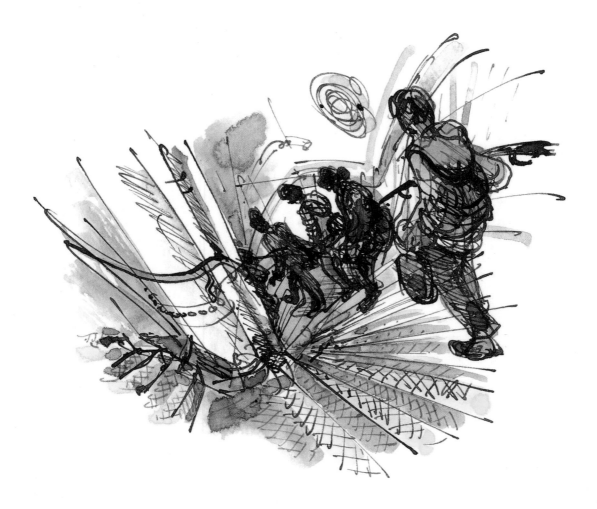

Spiral staircase at Camden
Town Underground station

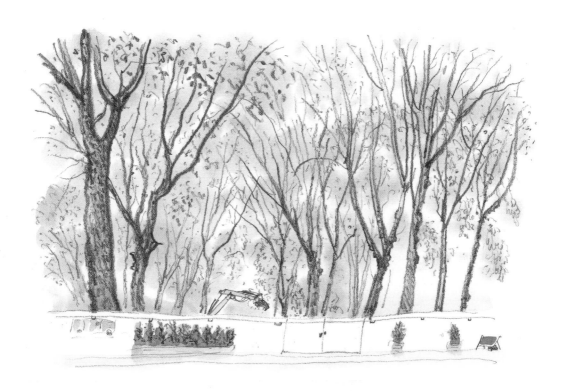

Top: St James's Gardens being destroyed by High Speed 2, 2019

Bottom: St James's Gardens from Hampstead Road, 2017

In Camden Gardens there is a bizarre interplay between rail and road, in which rail had the upper hand when a line of handsome villas along St Pancras Way was broken into by the railway's arrival. In winter, the gardens are bleak but clear and open, whereas in spring and summer they are quite idyllic. The surrounding ugliness is half-hidden; buses terminate restfully in groups in the street beside them, students use them for photo shoots and the grass is good for sleeping on.

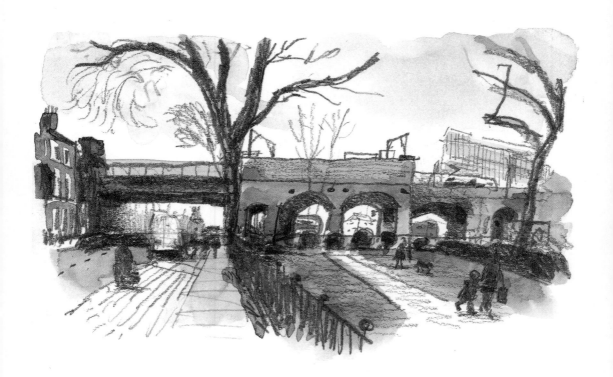

Camden Gardens, 2019

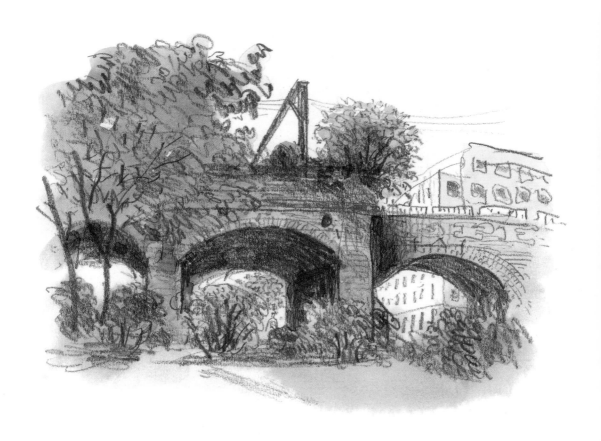

Overground bridges at Camden Gardens, 2018

I like Camden Road station on the Overground line – the spacious booking hall, the views over Camden Town from the platforms above and the amazingly long goods trains that pass through while you wait for yours.

Here again the railways made heavy demands on the local architecture, which had to knuckle under and make the best of it, as the pub in the drawing below did. At Chalk Farm the old Round House, built to turn steam engines round, has transformed itself into the splendid Roundhouse venue.

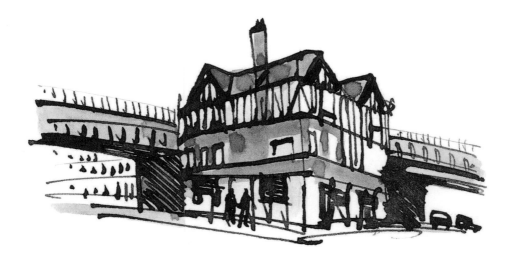

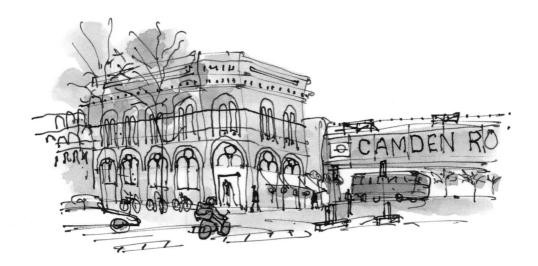

*Top: Overground
rail and pub, 2017*

*Bottom: Camden Road
Overground station, 2017*

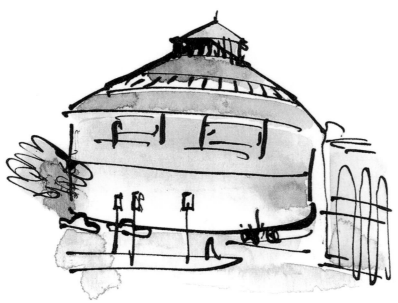

Park

At Camden Town's western border lies Regent's Park. Its general style is formal and it is surrounded by splendid terraces, almost invisible in summer when the leaves are out but easy to take in as a whole when the trees are bare. I love the long straight Broad Walk that runs unbroken through the park from north to south. The terraces' architect, John Nash, had originally intended there to be a long strip of water beside it, but instead there are rows of trees four lines deep on either side along the northern stretch and orderly flowerbeds along the southern. Yet despite the general air of order and neatness in much of the park, other parts of it have been allowed to remain unmown, or sown with beautiful wild flowers as a reminder of the more laid-back aspects of this stunning public space.

The whole park is an astonishing survival of openness and distance in the middle of a crowded city, with continual surprises, wonderful details and spectacular sunsets. I particularly like drawing the lake, with its pretty islets and the floating birdlife they attract. The enormous annual Frieze Art Fair and Frieze Masters is now the biggest annual commercial event in the park, whereas its offshoot, Frieze Sculpture, enlivens its seperate open-air patch where everyone can be intrigued by the works while also enjoying their verdant surroundings.

The approaches to the park reveal its less prom-
inent features, like the magnificent archways
at either end of Chester Terrace, their lettering
beautiful compared with the Inverness Street
Market sign. On hot summer nights in the cres-
cent, when the breeze is in our direction, we can
still hear the cries of the Zoo's fed-up animals.

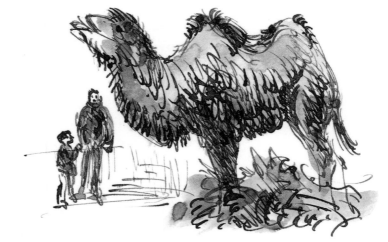

*Overleaf: Cumberland
Terrace, 2018*

*Top: Bronze figure near
Gloucester Gate, 2017*

Middle: Park Village West, 2017

*Bottom: Camel in
London Zoo, 2018*

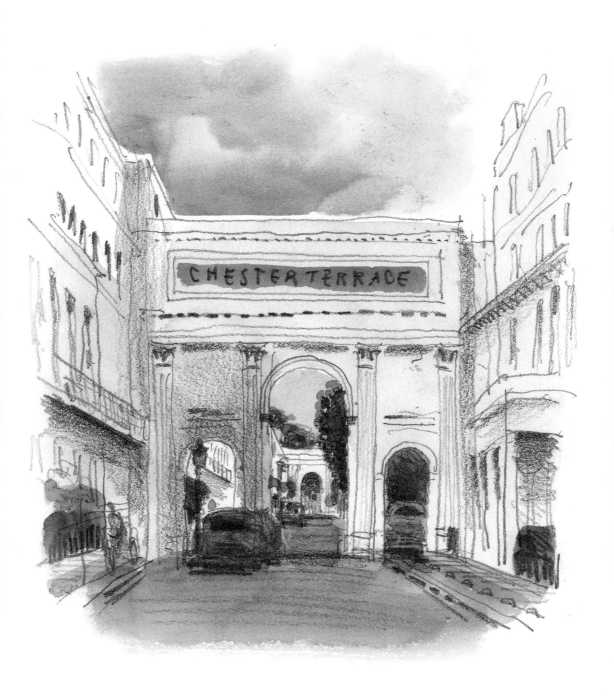

Archway to Chester Terrace, 2018

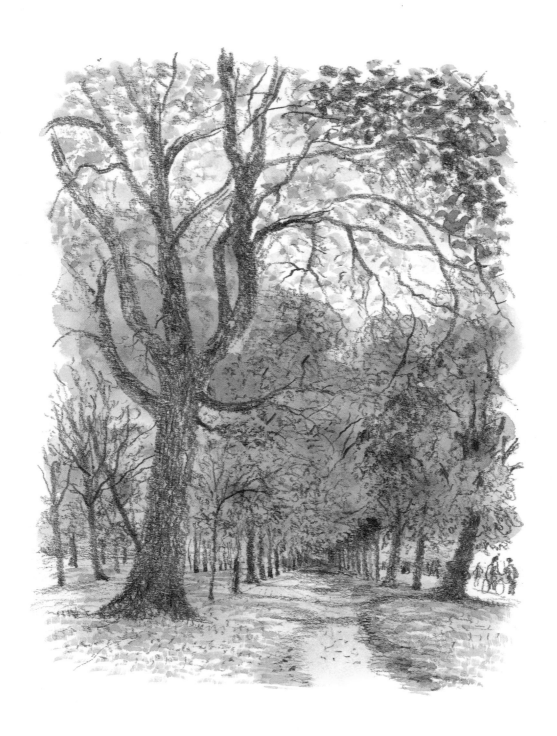

The Broad Walk in spring, 2018

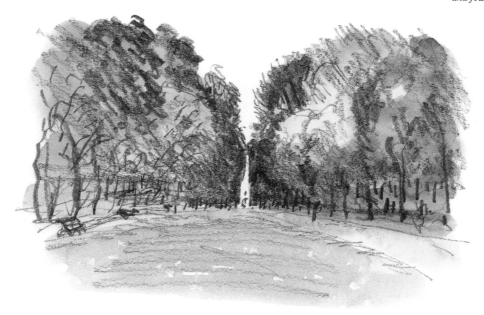

There are two big open spaces within the park: on the east, the fairly flat area in front of the Nash terraces, used for playing rugby and practising helicopter landings; to the west, the vast empty area sloping gently downwards away to the west of the Broad Walk and used mostly for cricket and football. Around it are several clumps or clusters of trees beneath which the grass, cow parsley and wild flowers are left unmown and, in May or June, looking enchantingly jungly and impenetrable.

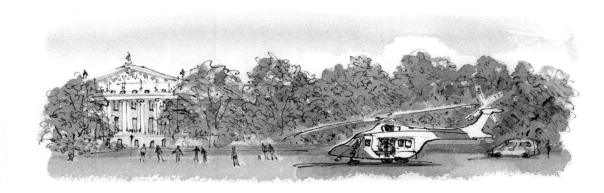

Top: A helicopter landing near Cumberland Terrace, 2018

Bottom: View to the west from the Broad Walk, 2018

As you reach Hanover Gate, the minaret of London Central Mosque rises beyond the boating pool with its yellow plastic canoes. (The Boating Lake's plastic boats for grown-ups are bigger and blue.) The stretch of canal running through the park ends here with Quinlan Terry's fairly recent row of pastiche classical, baroque and rococo villas arranged like an architectural exhibition on the park side. Across the canal from them in London's second-biggest garden is the US ambassador's residence, the pretext for the thundering fleets of enormous military helicopters that periodically deliver American presidents dropping by on state visits.

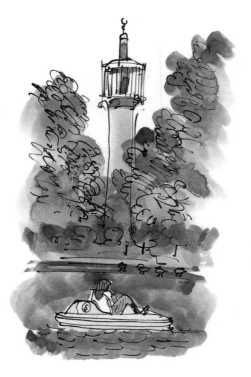

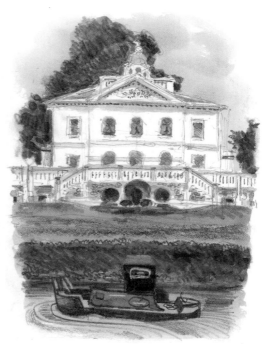

Left: Boating Lake near
London Central Mosque, 2018

Right: Regent's Canal:
Villa on Outer Circle, 2018

Regent's Park's most distinguished modern
building is Denys Lasdun's Royal College
of Physicians at its south-eastern corner,
opened in 1964.

Regent's Park's visitors, 2018

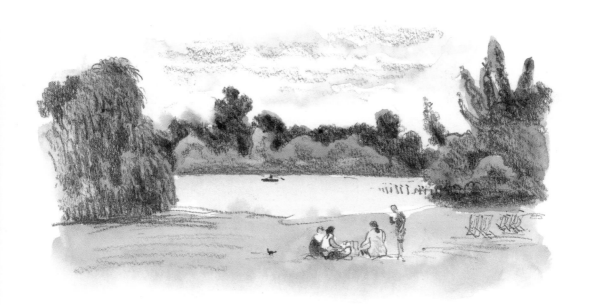

The Boating Lake, 2019

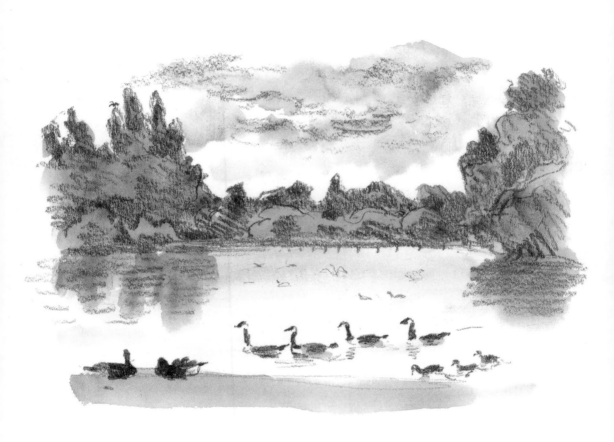

*Geese and ducks on
the Boating Lake, 2018*

Park

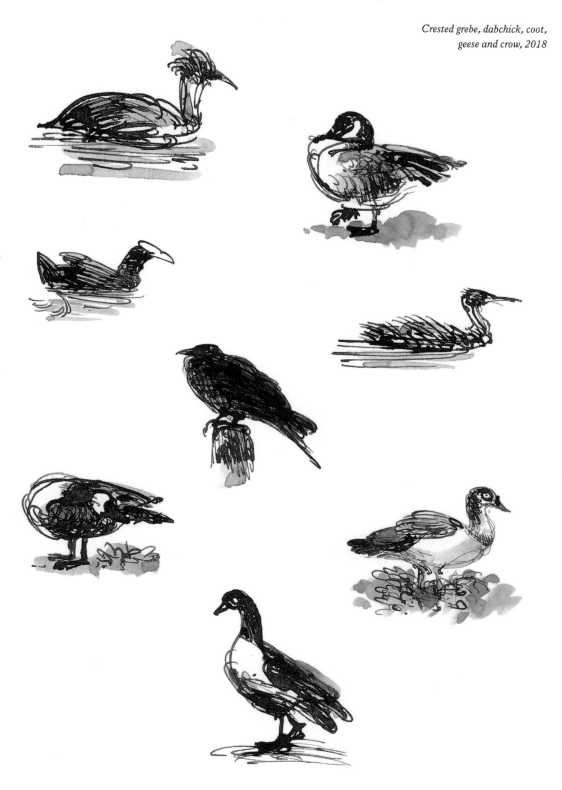

Cumberland Terrace is John Nash's longest and grandest neo-classical work, yet it was unfashionable and run-down after the war and in 1962 almost demolished. From the Broad Walk you can take it in as a whole, with the tops of the Ampthill Estate high-rises in the background.

It is most spectacular in afternoon or evening sunlight. It looks lovely in winter and spring, but is almost invisible at the height of summer except for a few gaps in the trees, which is when I like it best as a subject – drawing a detailed elevation of a very long terrace can get tedious.

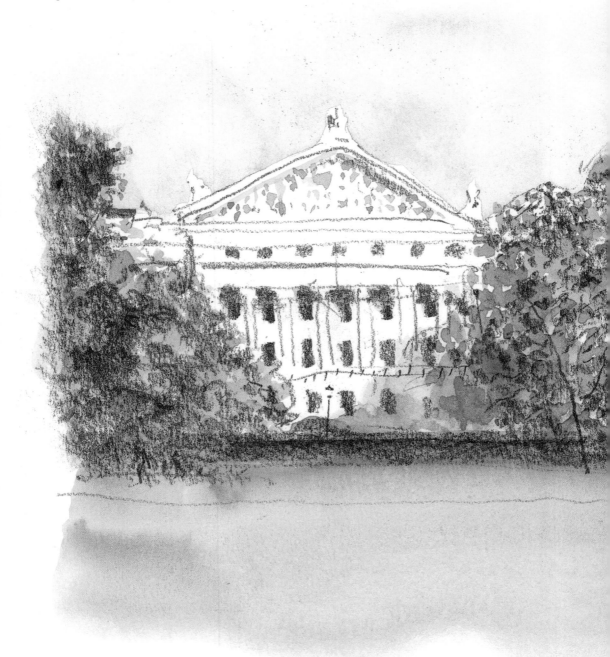

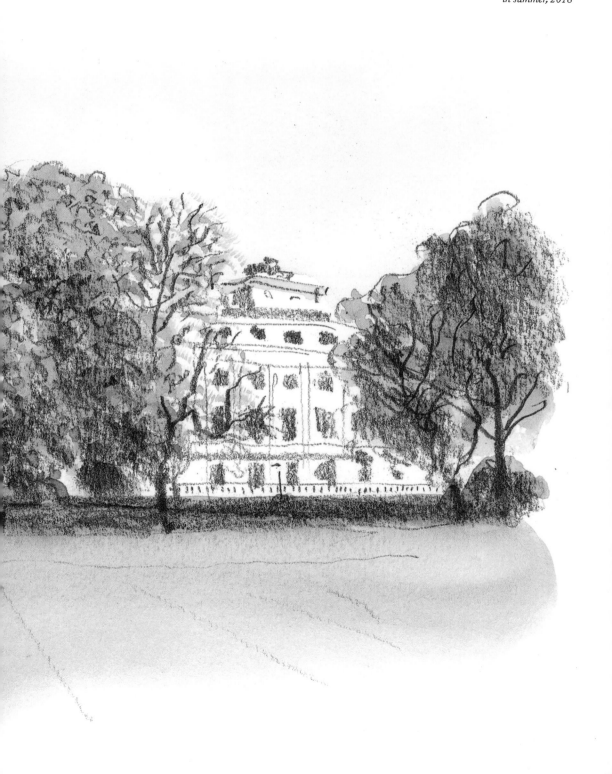

*Cumberland Terrace
in summer, 2018*

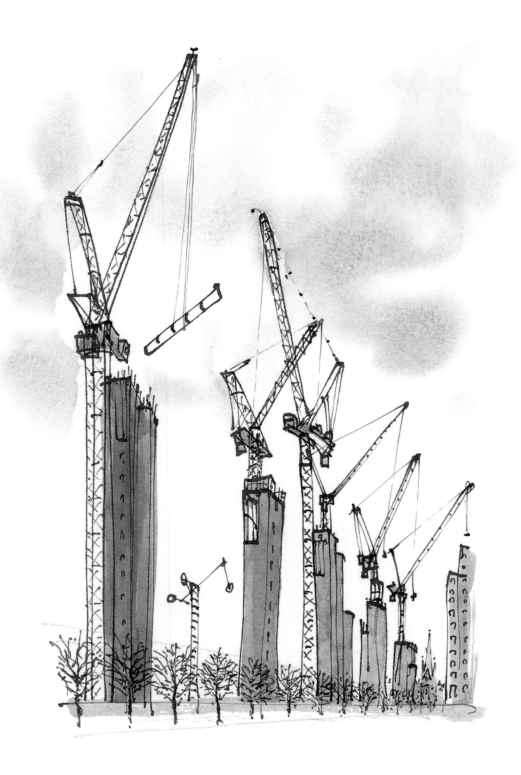

Canal II

Returning to the towpath at Camden High Street's bridge, the south-eastern stretch is strikingly different from the previous western section, but is just as good to draw because of its levelness, its ever-changing reflections, and its vivid architectural contrasts of old and new. It's also interesting for the things floating on it – boats, barges, birds, beer cans and plastic bottles, seasonal pondweed, and beneath them less idyllic non-floaters like fish, eels, dead dogs and pigeons, and occasional sunlit glimpses of a muddy bottom.

The canal was the area's earliest big commercial venture, but in the early nineteenth century it had to wend its way downstream between existing rural properties, so to begin with it still twists and bends quite confusingly. More recent developments – among them the steel and concrete flats behind Sainsbury's – have sanitized the open spaces beside the towpath, which lead on to the rougher and less predictable feel of the next long straight and more commercial part. Eventually, just beyond another lock, you reach a striking new metal footbridge that leads across to Camley Street's nature reserve. From this bridge you can see in the background the cluster of old gasometers recently converted into well-designed flats. A little further on, seen across the canal from the wonderful Granary Square, pencil-thin concrete lift shafts are rising for a development that will shortly blot out the sky between them.

Towpath life – dealing, bikes, fights between coots and (*overleaf*) between people. A short but pretty terrace of houses stands opposite some relatively modern flats in their own gated area. The canal has only one offensive downside: the tedious and repetitive graffiti, amateurishly sprayed on any accessible surface.

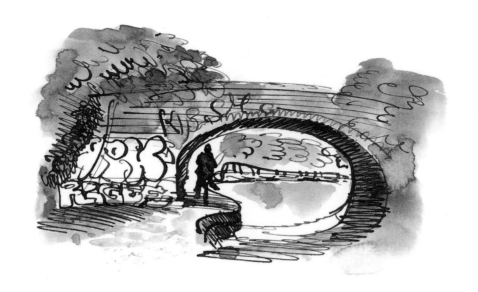

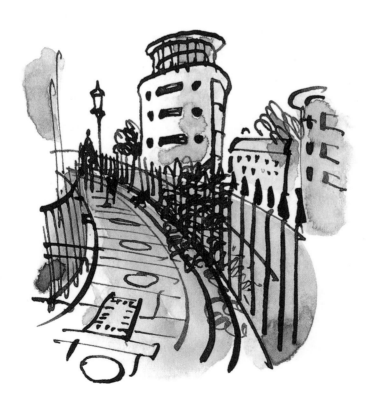

Canal near Camden Road, 2018

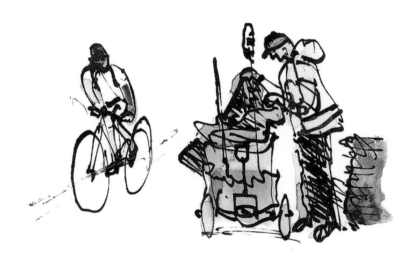

Canal II

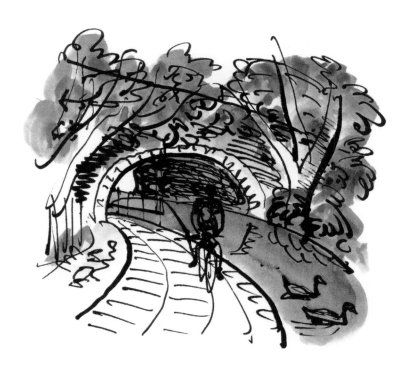

Canal near Lyme Terrace, 2018

Every spring the trees and the undergrowth
still astonish me by the power of their sudden
growth to transform the most ordinary subjects.
It was noticing the idyllic towpath scene below
that made me want to do this book. A walk on
the towpath is full of surprises and delights: the
silent cyclist behind you; the bare toe poking
out of a slit in a dome tent's canvas.

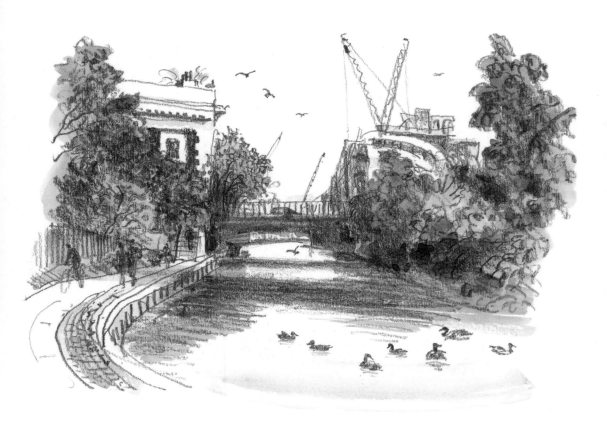

Canal towpath under
St Pancras Way, 2018

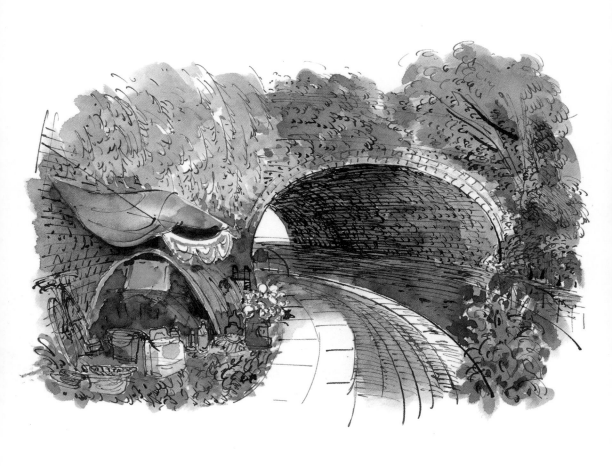

*Above: Encampment by Royal
College Street bridge, 2018*

*Overleaf: Canal near Camley Street
with gasometers on the west bank, 1984*

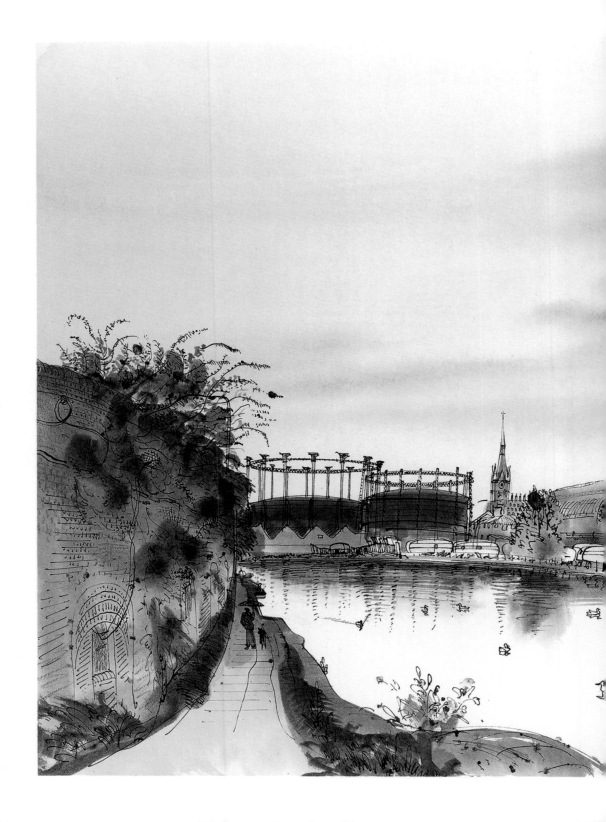

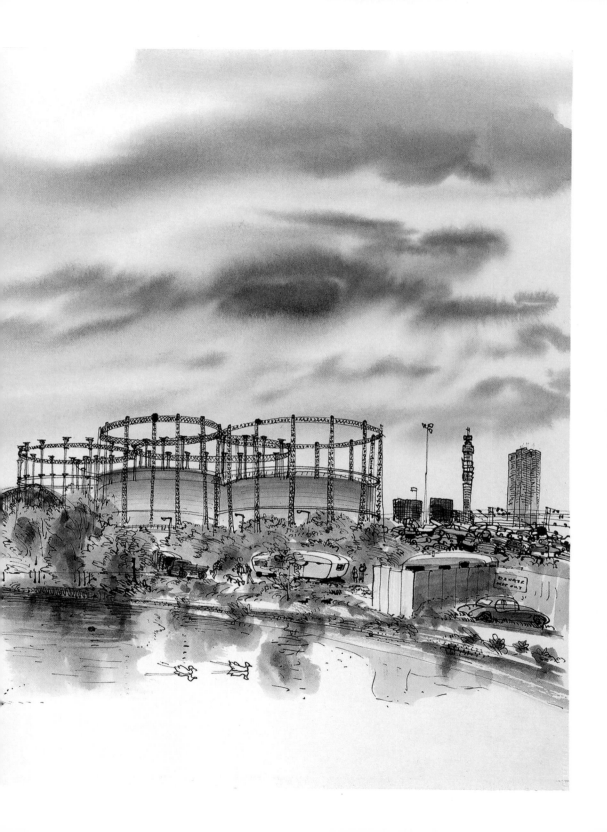

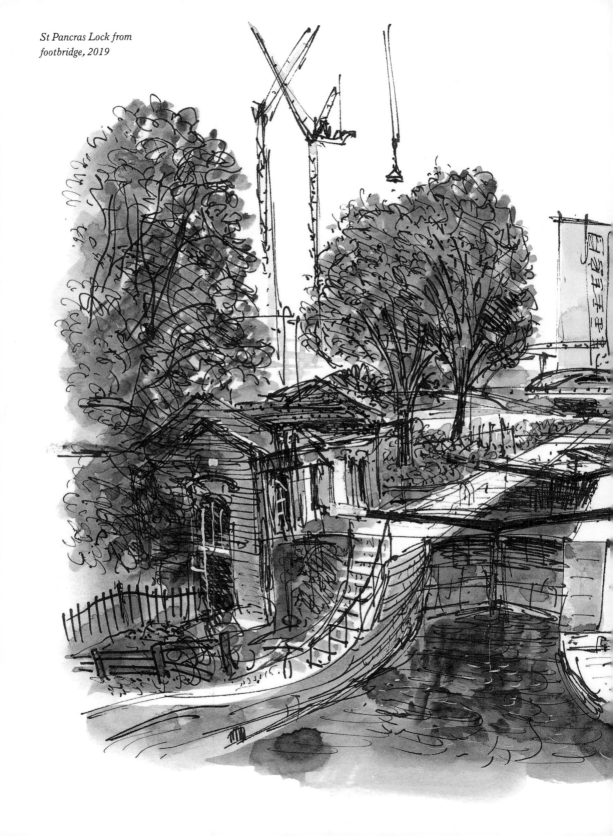

St Pancras Lock from footbridge, 2019

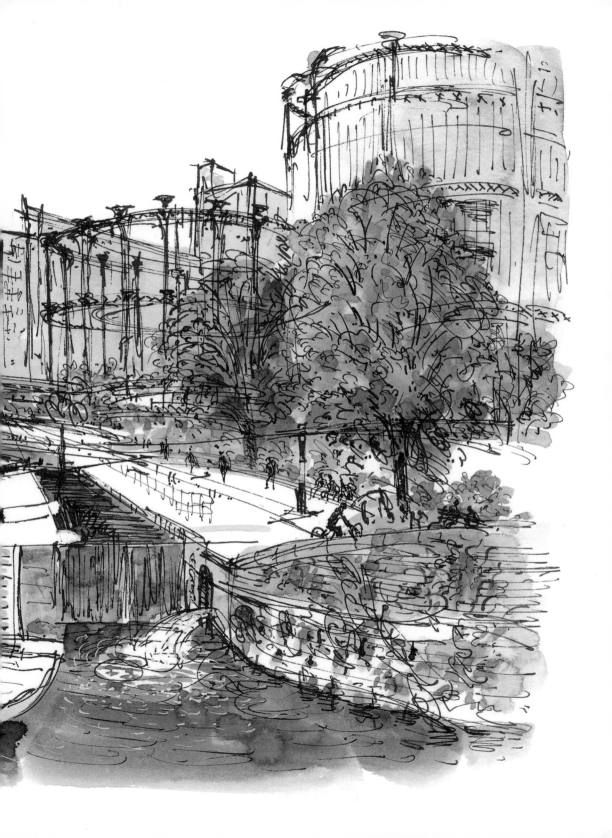

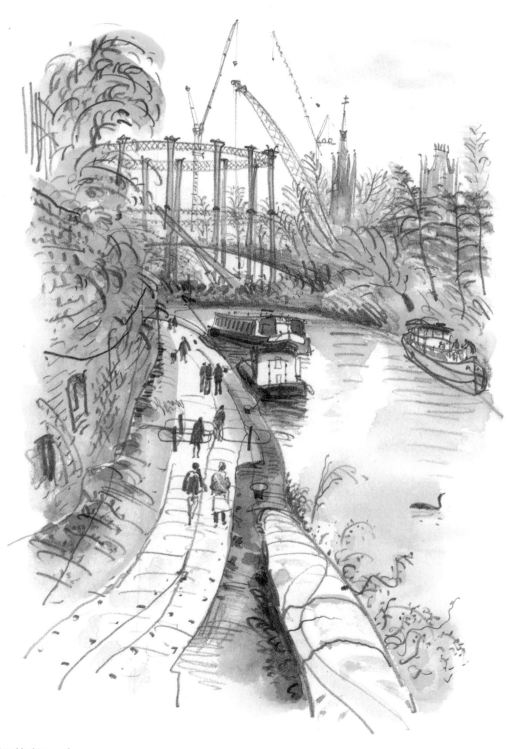

*Canal looking south
from Camley Street lock, 1984*

Canal II

These drawings were made quickly and finished on the spot. A drawing can be quick or slow, slight or serious; a rough sketch, jotted down as if in shorthand, or more careful and deliberate – it doesn't matter which. I enjoyed exaggerating the curvaceous swoop of the Coal Drops Yard roof, and didn't mind letting the old gasholder look more rickety than it really does. The canal drawing opposite took a bit longer, its light touch of watercolour adding a hint of autumn.

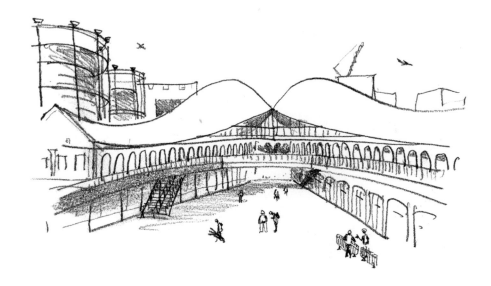

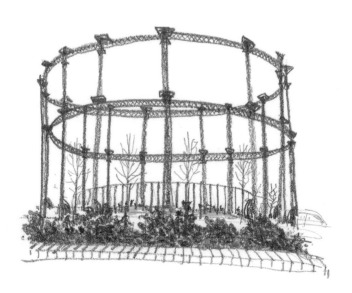

Top: Coal Drops Yard
under reconstruction, 2018

Bottom: Gasholder now
moved across canal, 2019

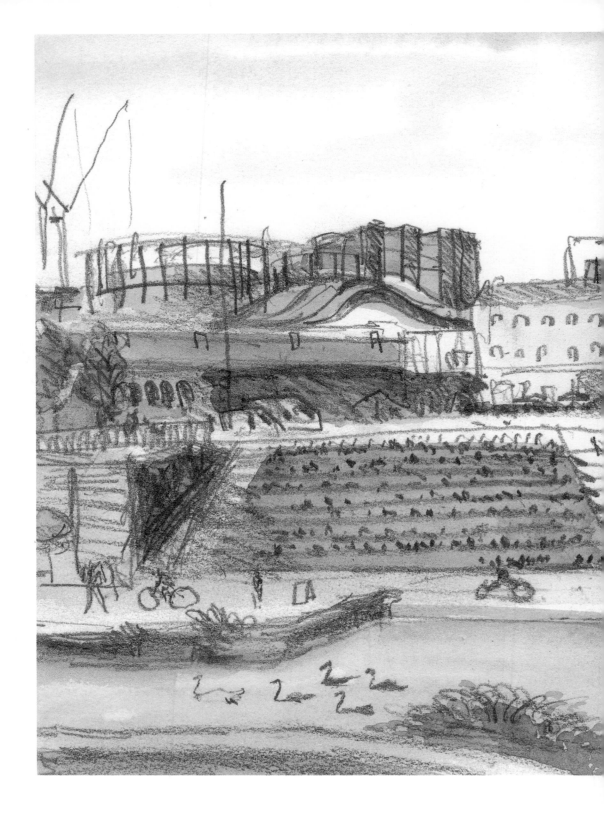

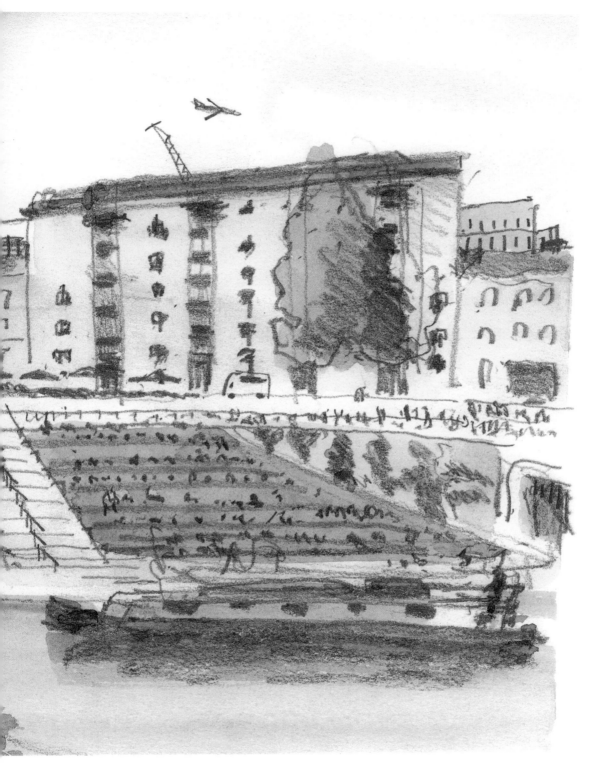

Granary Square from the canal, 2018

*Granary Square and Central St Martins from
the first-floor terrace of a pub, 2017*

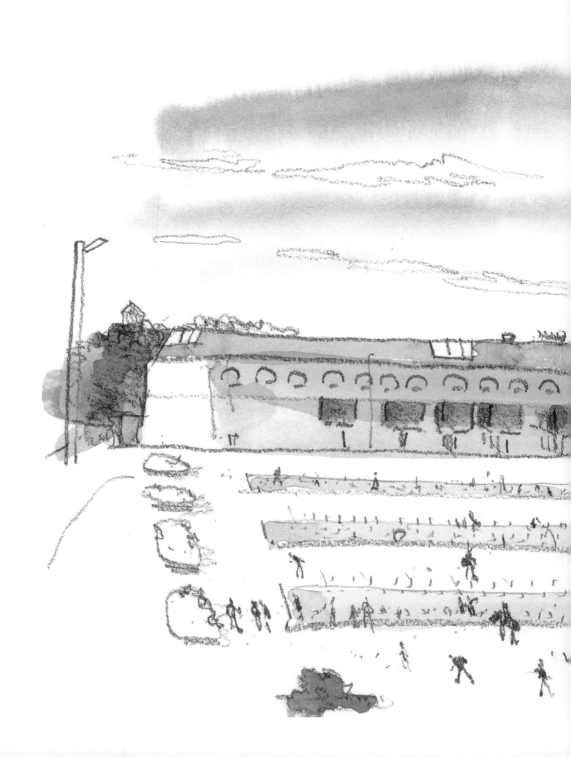

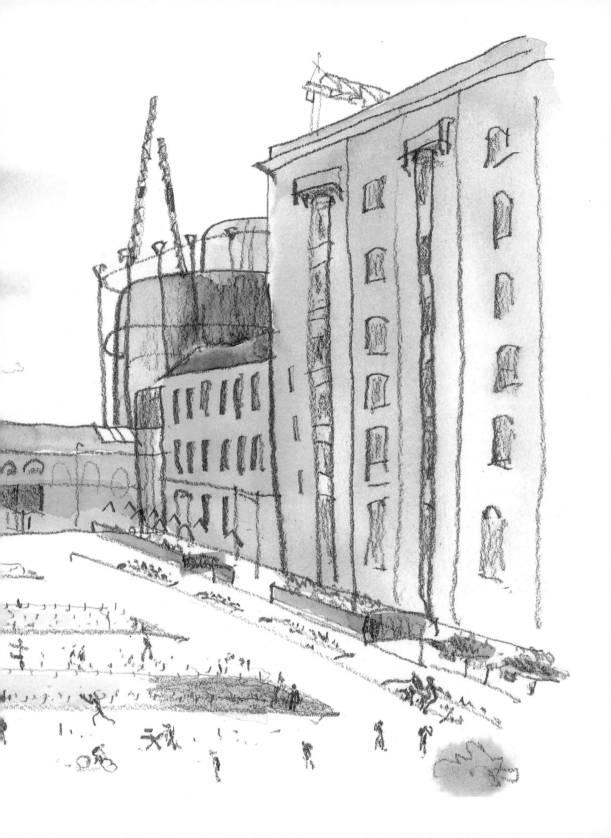

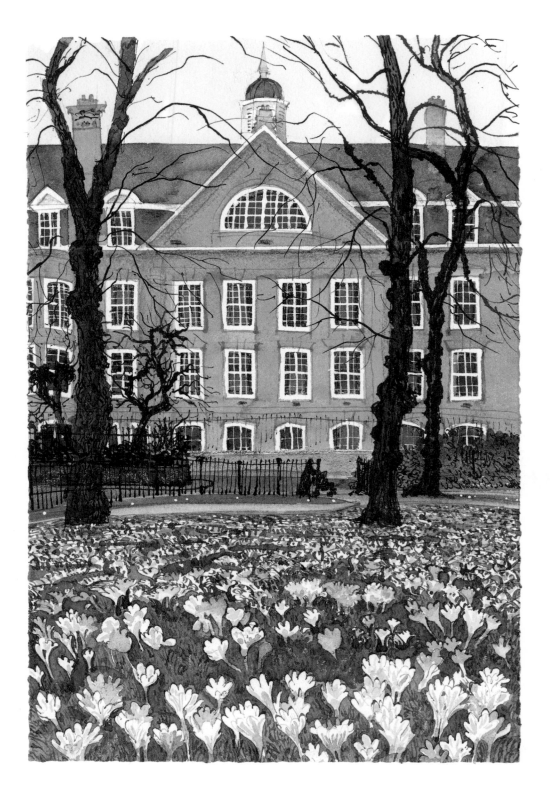

Squares and Crescents

Besides the attraction of its many landmarks and inhabitants, I've enjoyed living and working in Camden for its abundance of squares and crescents, which offer different opportunities and challenges when I try to draw or paint them. Some are mysterious and tucked away, others are magnificent and unmissable. I like drawing the squares (even when they're not really square at all) because they're full of trees, peaceful, surrounded by hedges and railings, and usually free from traffic. They're also enlivened by people exercising, playing games and looking after children.

Crescents are more tantalizing because, horizontally at least, they have no straight lines. Gloucester Crescent, the oval-shaped one I've lived in for sixty-four years, hasn't changed much except at its far ends. I love drawing and painting it throughout the year for the beautiful momentary or seasonal changes of light and because it's quiet and seldom very busy, filling up with traffic only when there's a hold-up somewhere else. I've drawn and painted these squares and crescents again and again because technically they're difficult to get right, and aesthetically because they're each individual and always beautiful. Returning to a subject is worthwhile because weather and season are always different and each time one quite literally sees it in a new light.

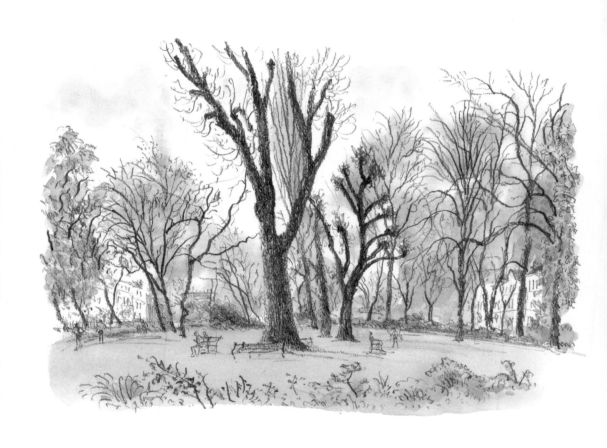

Overleaf: Oakley Square, 2019

Above: Camden Square, 2019

Squares and Crescents

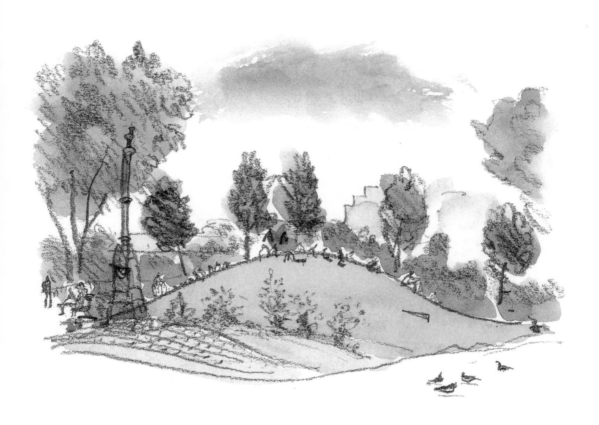

St Martin's Gardens, Camden Street, 2017

Old St Pancras Churchyard (opposite) is both beautiful and historic, with John Soane's modest in scale but masterly mausoleum for his wife and and their son and in due course for himself too. In the 1930s the shape of its roof inspired Giles Gilbert Scott's once familiar red telephone boxes. The most memorable presence nearby is Hardy's Tree. The trunk of this big ash is ringed by a circle of ancient gravestones which were placed round it by Thomas Hardy as a young man while he was still an architect. Because the churchyard was quiet and relatively remote, it was the haunt of Dickens' bodysnatchers in *A Tale of Two Cities*. Even now, still quiet and peaceful, it's said to be London's most undisturbed venue for drug-dealing.

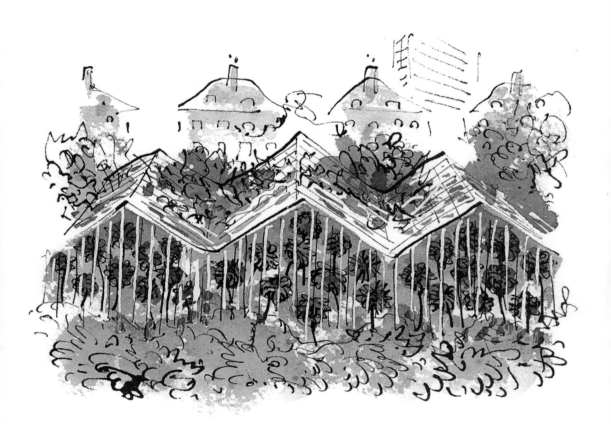

Rochester Square, c. 2014

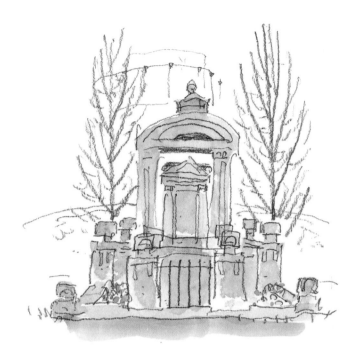

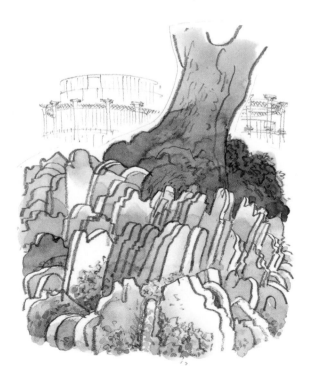

Chalcot Square is a square that really is square,
and makes a pretty and leafy playground for the
children of the surrounding houses. Ted Hughes
and Sylvia Plath would have seen this view
every time they stepped out of their front door.

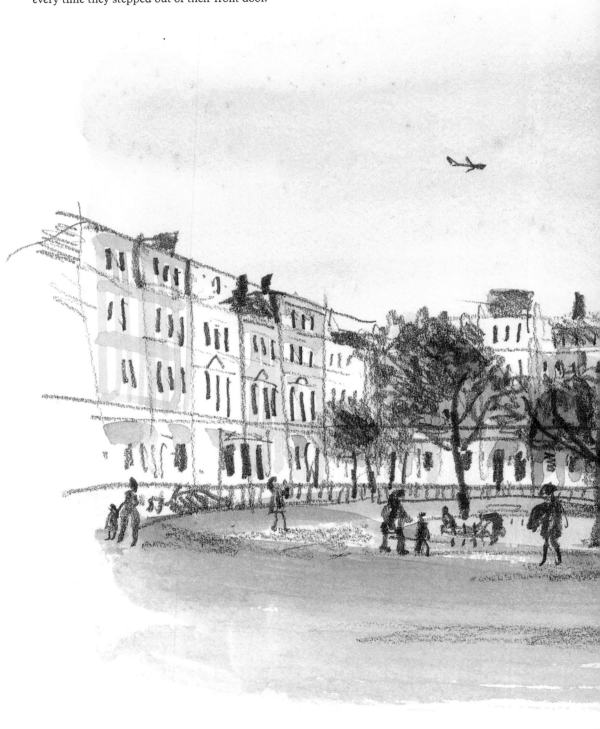

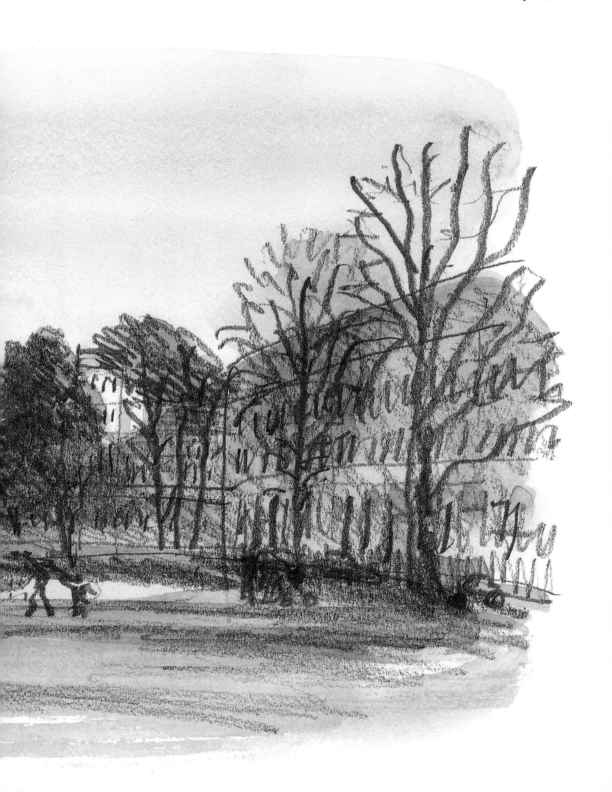

Chalcot Square, 2019

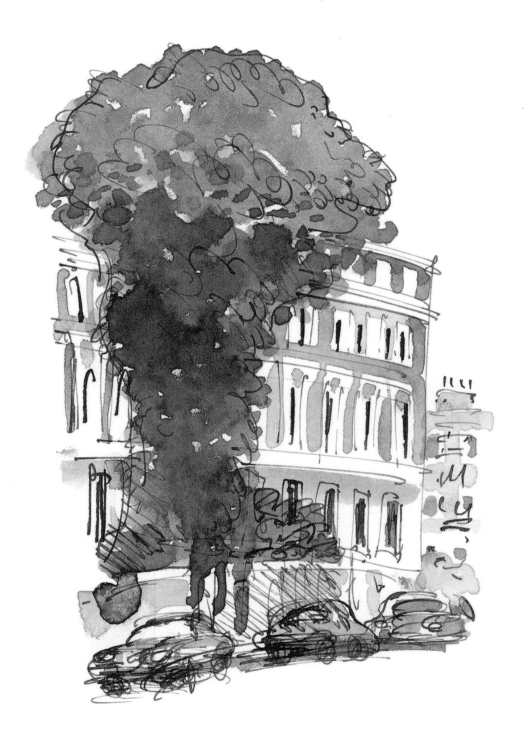

Gloucester Crescent, 2018

Quick, slight drawings originally intended only as rough sketches may have an unexpected lightness of touch or they may be rubbish. But more careful or deliberate ones might just be earnestly boring. I can't always tell, and asking other people simply adds uncertainty. Both ways have their virtues and drawbacks, and both need the other. In any case, time tells – it's easier to be objective about something you drew ages ago.

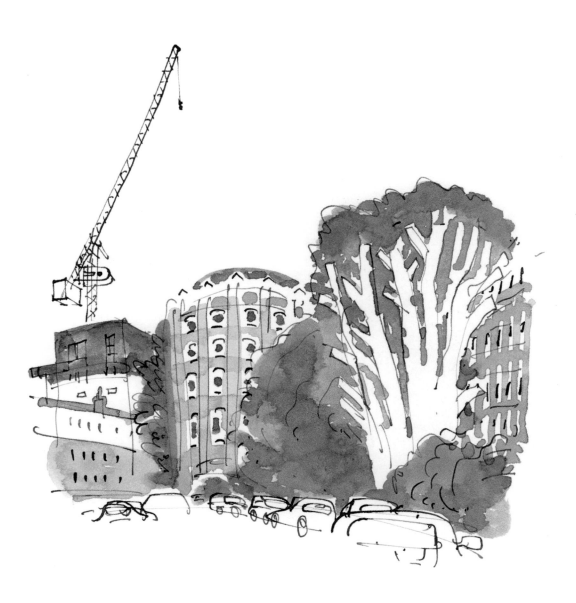

Gloucester Crescent, 2017

Gloucester Crescent's most striking feature is a long, curving and symmetrical stretch of terrace with a central classical pediment and two ornamental towers at each end. Drawing it is further complicated by its being built on a slope, so each individual house is slightly notched up or down from the next. Its ground floor and the pavement in front are also usually hidden by parked cars, so the precise relation of each house's facade to the next has to be checked.

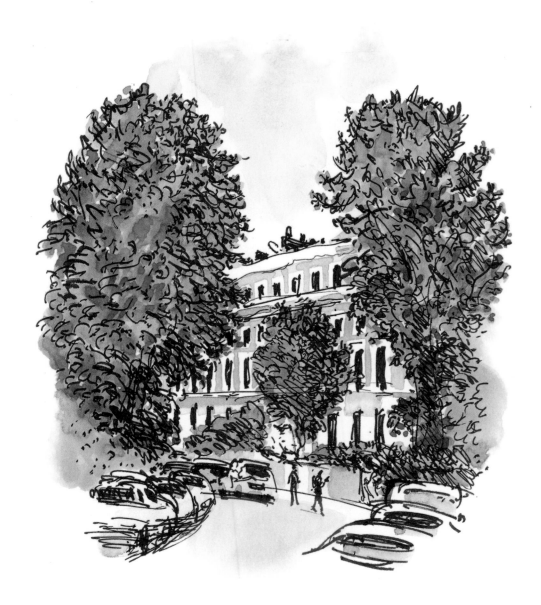

Gloucester Crescent, summer 2019

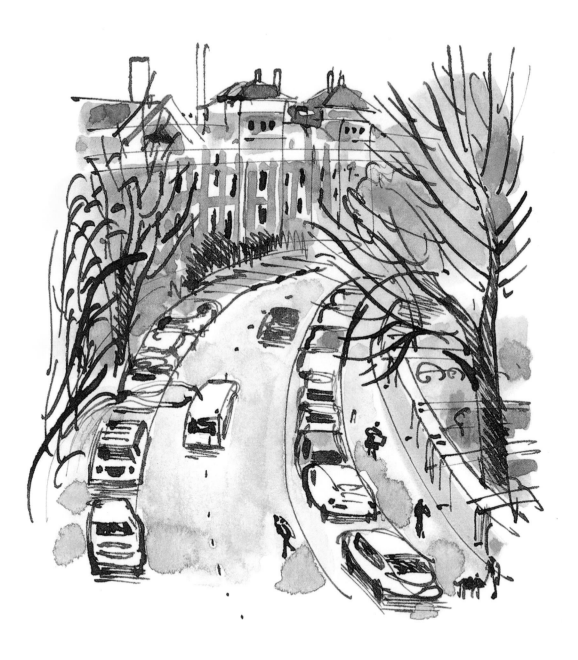

Gloucester Crescent, autumn 2018

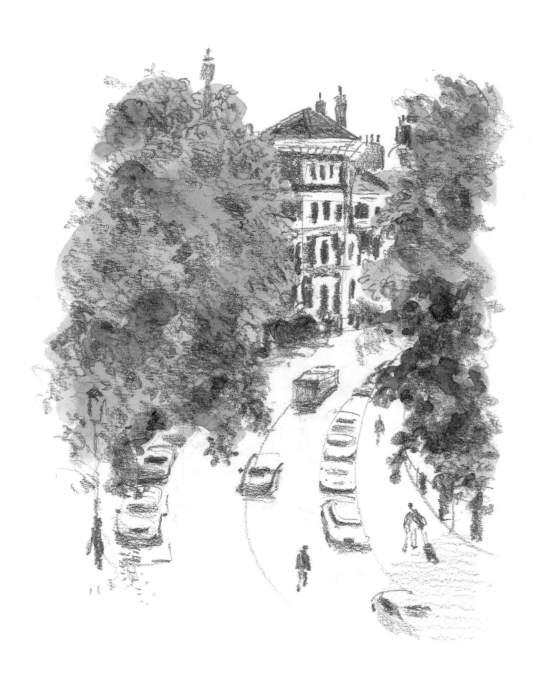

Gloucester Crescent, summer 2019

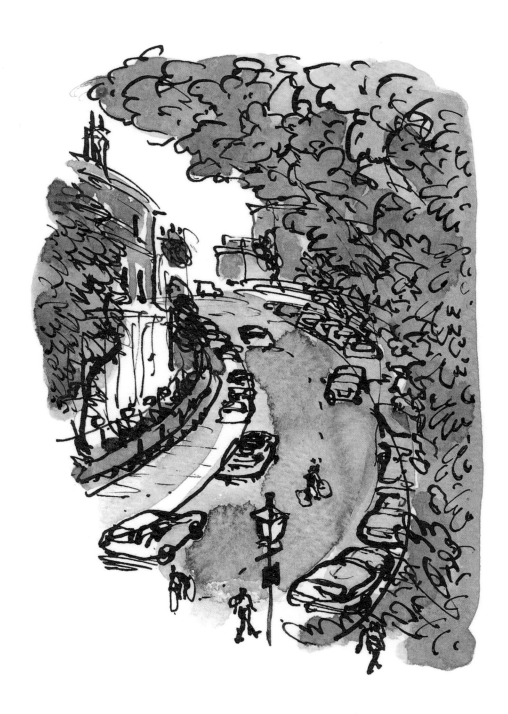

Chalcot Crescent must have been planned to fit as many dwellings as possible into a limited space. It's the only S-shaped crescent I know, swirling first to left and then to right. The curves are complicated, beautiful and intriguing. It's difficult to draw them accurately, but draw-ings needn't always be accurate: I've removed the parked cars, which in reality only happens when the place is being re-tarmacked or filmed. Balcony railings, glazing bars, street railings, pavement kerbs and parking lines all follow and emphasize the sinuous curves.

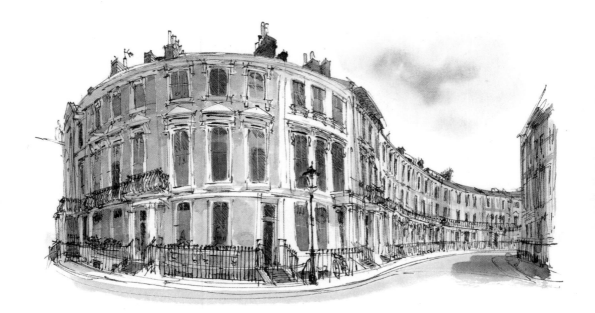

Chalcot Crescent, 2019

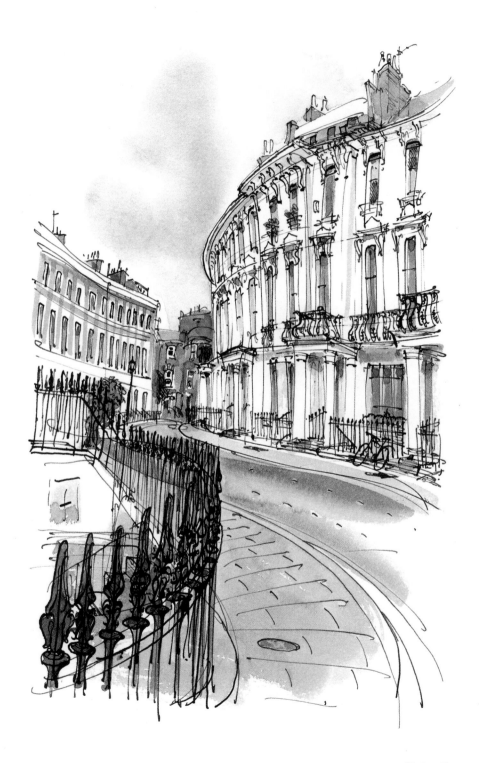

Chalcot Crescent, 2018

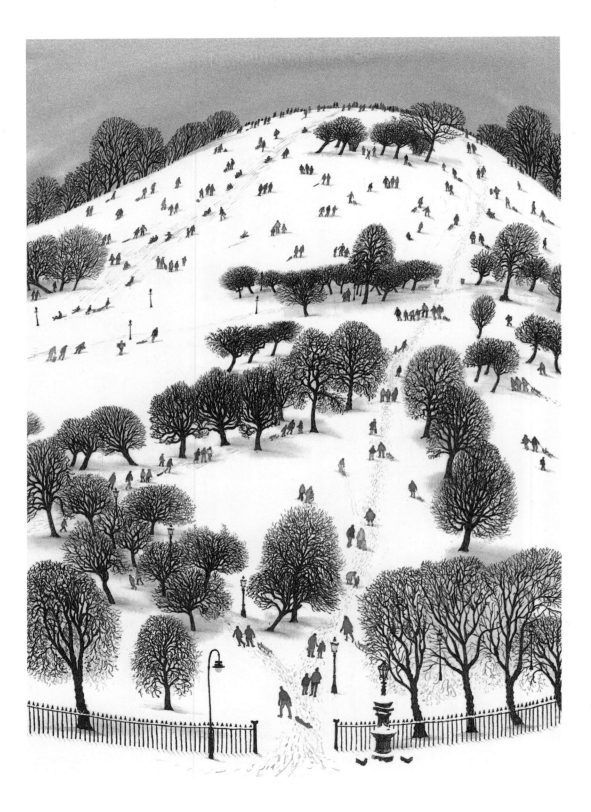

Hill

Primrose Hill isn't big enough to be seen or even much noticed from far away, and it's not especially dramatic to look at even when you're strolling up it. But the closer you get to the top, the more impressive and steeper it seems, and from its summit you realize what's wonderful about it – the views are spectacular, the best there are in London.

In winter, its bare trees reveal the tastefully pretty pastel-coloured stucco villas that edge the hill; in early summer, the lush long grass conceals people sitting and lying on the upper slopes, and you can only see their heads and shoulders. On sunlit autumn days, as the trees lose their leaves, the hill turns golden brown; it is bleak but brisk again in winter, and occasionally there is a snowfall – an annual certainty in my earlier years here, but now a brief but much-loved surprise.

My first childhood memory of the hill was that there were no primroses, and there still aren't. But there are pleasant paths, pretty lamp-posts, lovely trees, plenty of space, people and dogs, and except on Bonfire Night and New Year's Eve it doesn't shut at night. Over the years I've often drawn it because it's nearby, always beautiful and different, and has the clearest views of the distant City and West End, forever changing and transforming; but also maybe because I'm continually changing too in the way I look and think. All these things make it my favourite place.

Top: Regent's Park Road, 2019

*Bottom: Primrose Hill
Primary School, 2019*

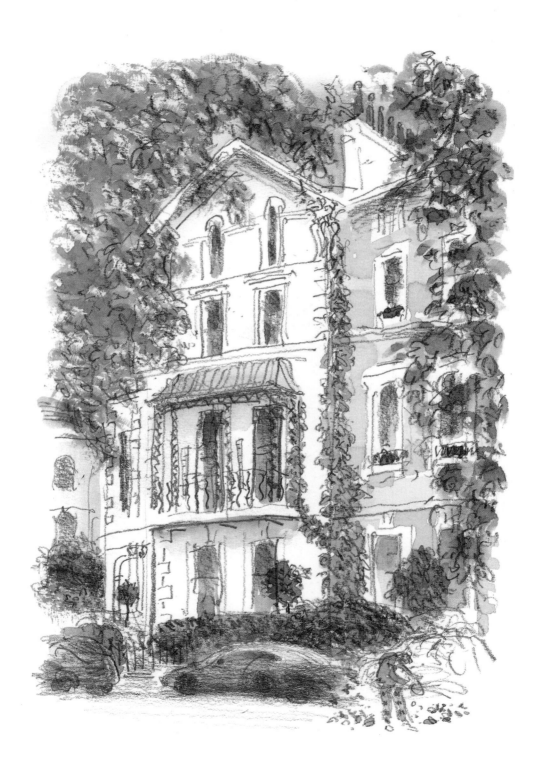

Albert Terrace from Primrose Hill, 2018

Primrose Hill's shops and cafés on Regent's Park Road are smarter and more individual, leisurely and upmarket, the crowds sparser and the people a notch less cosmopolitan than in Camden Town itself.

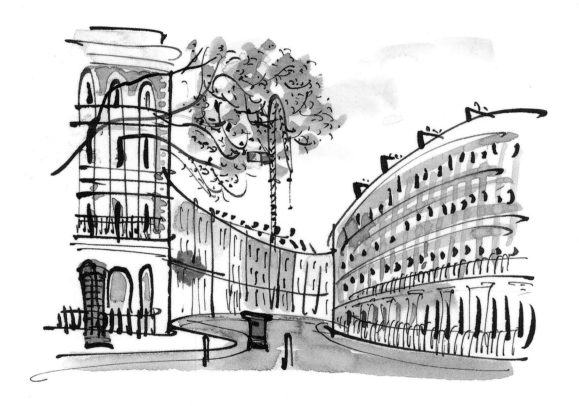

Regent's Park Road from the corner of Primrose Hill, 2019

Hill

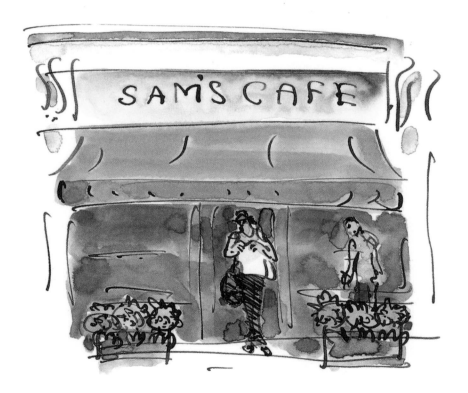

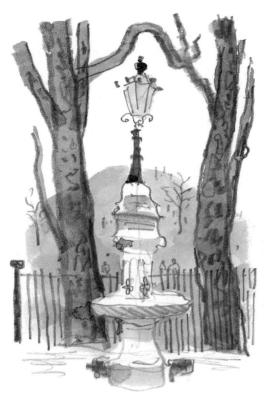

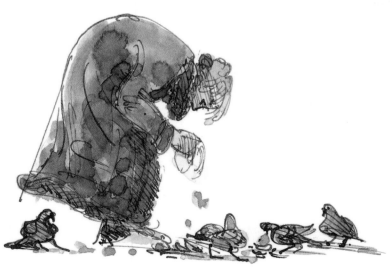

Feeding pigeons, 2019

Hill

In winter, before you begin to climb the hill,
the asphalt paths pass through fresh-looking
but occasionally quite squelchy parkland.

*Above: Primrose Hill near
Albert Terrace, summer 2018*

The hill is lovely in early spring. The nearer you
get to the top, the less you notice the surroundings,
most of which are now behind you anyway. Some-
times, even on the first warm weekday in April, the
trees are still bare and there are few people about.

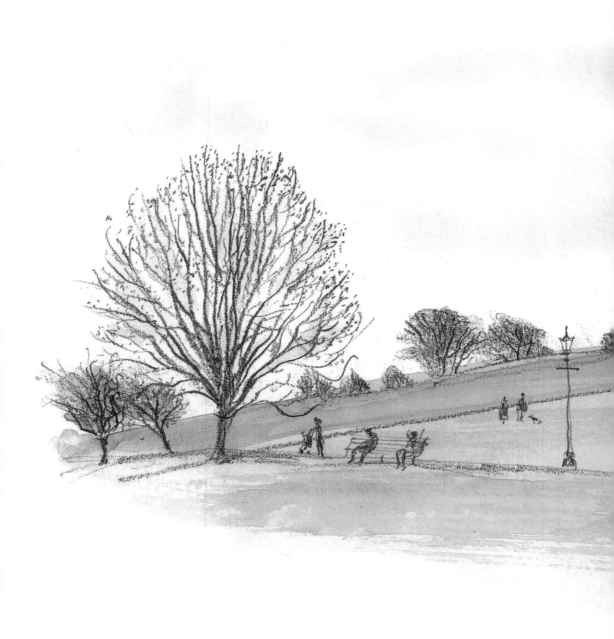

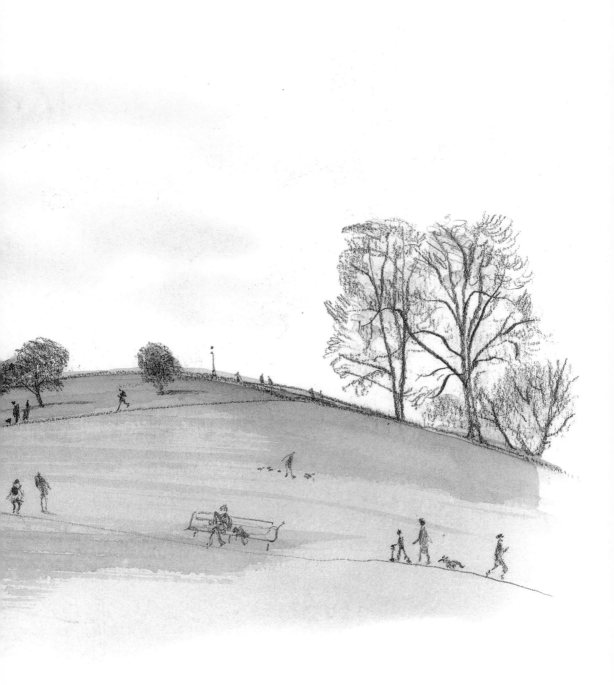

Primrose Hill, April 2019

From the summit, Canary Wharf, the City and
the West End are spread out before you, bristling
up on the skyline, with St Paul's passing in and
out of sight as you walk across the top. I drew
this view seated on one of the benches, the other
visitors' groupings, attitudes, opinions and
conversations becoming part of the experience.

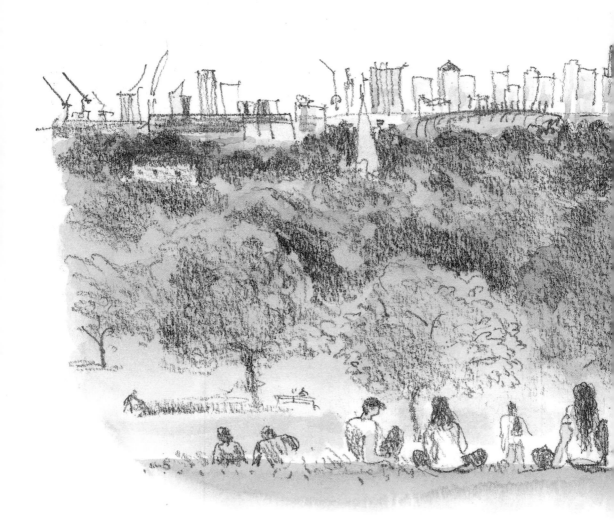

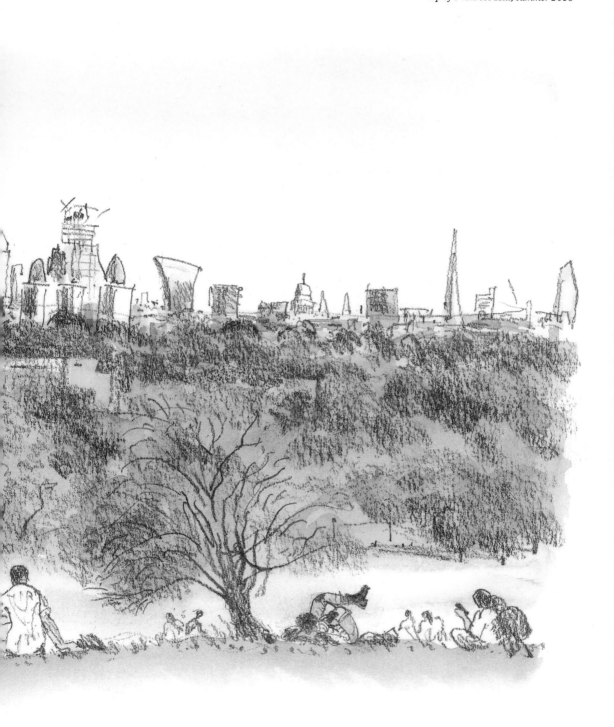

*Primrose Hill with the
BT Tower, autumn, 1981*

Hill

I'd long watched from the hilltop as BT's tower gradually rose. It was then the only tall high-rise on the horizon. The autumnal lithograph on the left was commissioned by BT in 1981 to celebrate the company's independence from Royal Mail (by then the tower was no longer being called the Post Office Tower). On the right is roughly the same view as it looks now in spring.

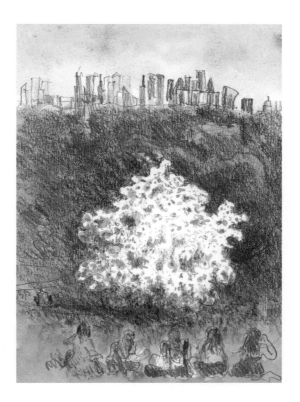

City skyline with hawthorn blossoms, May 2017

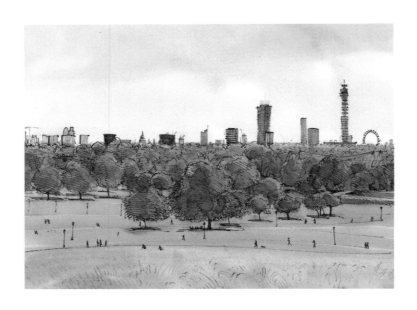

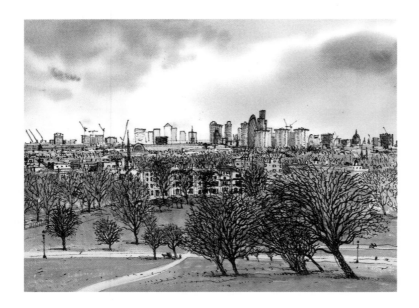

Top: Primrose Hill, June, c. 2006

Bottom: Primrose Hill, March 2007

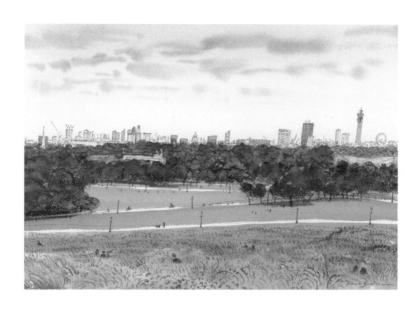

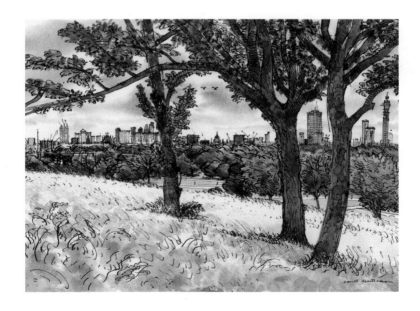

Top: Primrose Hill, July 2007

Bottom: Primrose Hill, August 2007

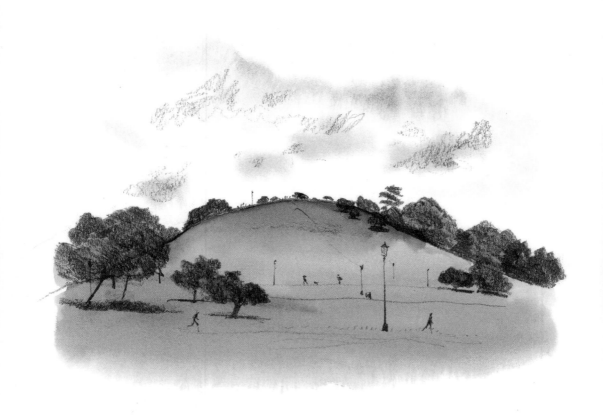

Primrose Hill seen from below, c.2016

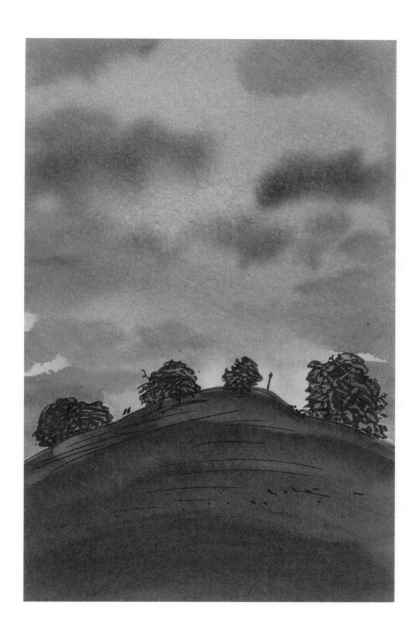

Primrose Hill seen from below, c. 2006

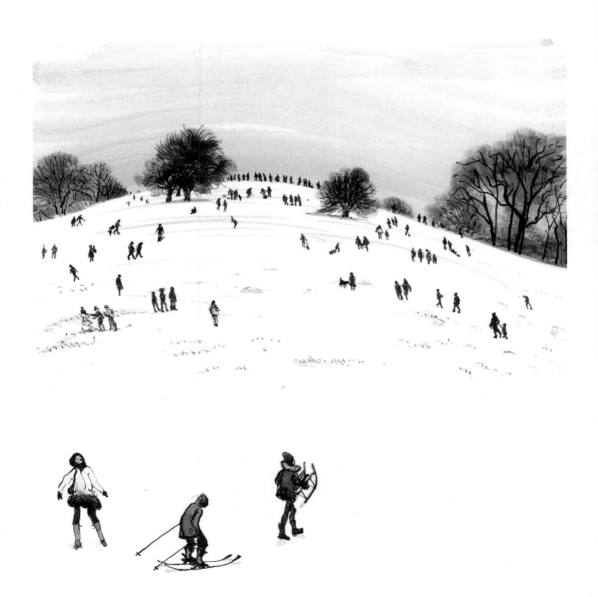

The hill under snow, February 2018

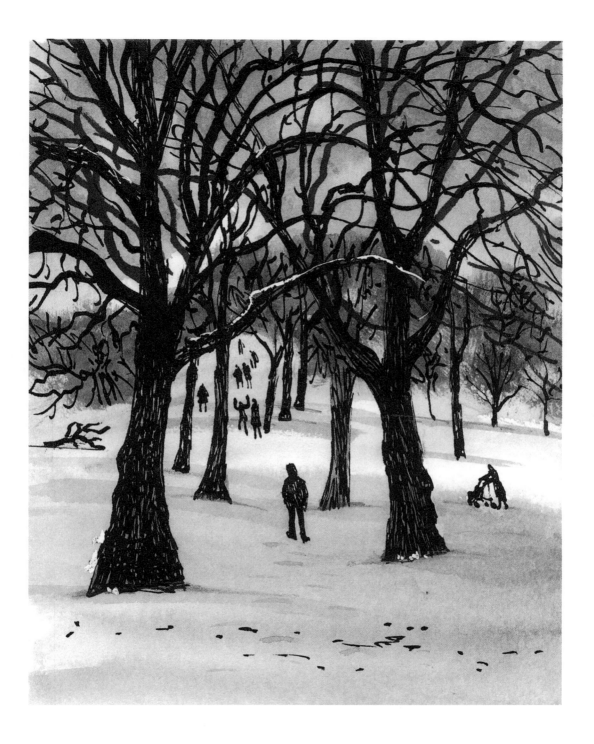

This was my first wood engraving of the hill, when there was still a proper gas lamp on the summit. The engraving opposite includes my younger children some years later. Both engravings were made in the warmth of the studio as Christmas cards. Snow makes everything else look black anyway, which is convenient for wood engraving, a medium which tends to make me simplify and formalise my subjects. In the first, the tranquil figures are at a safe distance beyond the hawthorns. In the second, they've become the main subject and it's the skyline, then surprisingly empty-looking, that's far away, like their childhood.

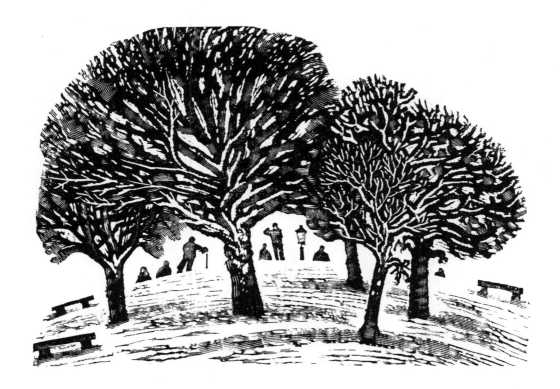

Primrose Hill, 1968

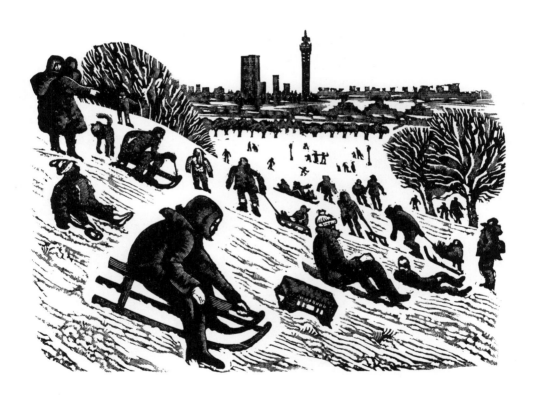

Primrose Hill, 1976